crochet
TO CALM

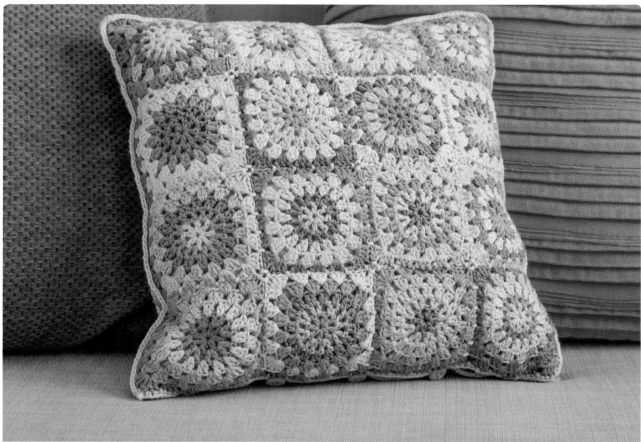

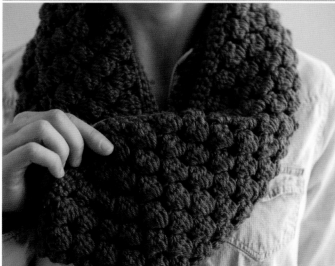

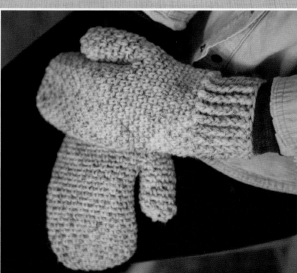

crochet
TO CALM

By the Editors at Interweave

Foreword by Mandy O'Sullivan of @craftastherapy

INTERWEAVE
interweave.com

dedication

To our wonderful readers! May you feel much calm and relaxation making these simple, elegant designs, and enjoy the results for years to come.

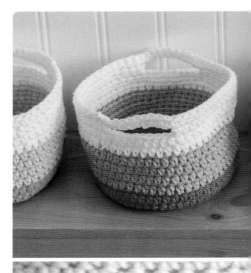

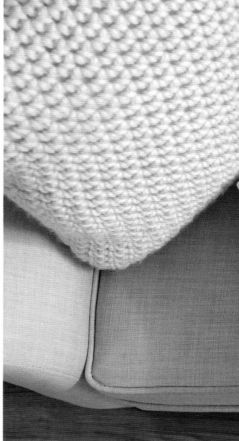

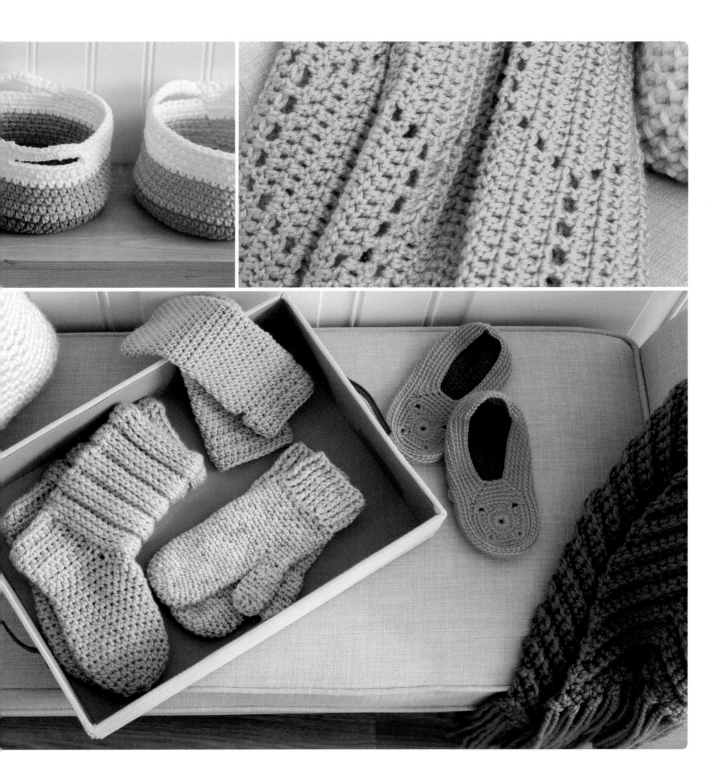

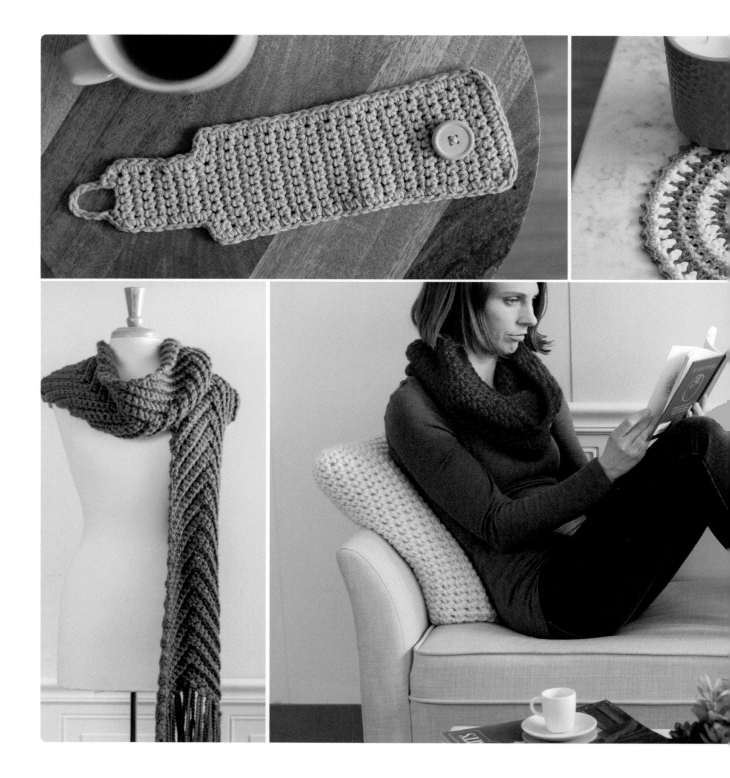

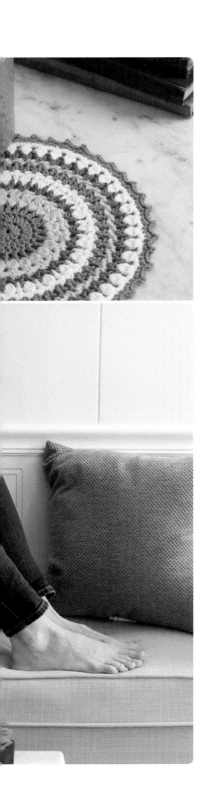

contents

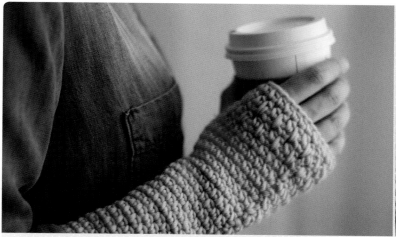
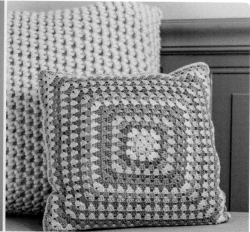

foreword

Welcome to Crochet to Calm.

I'm very excited about being a part of this fabulous book as I really believe in the therapeutic benefits of crochet. I've always loved creating things with my hands, but it was during a particularly stressful period of my life that I began to immerse myself in crafting as a way to calm and de-stress. An avid crafter since I was a child, it was a natural choice for me to distract myself from life's stresses by focusing on creative projects; playing with color, texture, and pattern has always made me feel happy. And since a close friend taught me how to crochet a few years ago, it's become my favorite way to unwind. Everyone is looking for some downtime, and crochet is the perfect activity to promote calmness.

I get an enormous sense of pride and accomplishment when I've created something from scratch, but crafting is more than that for me. It's an underutilized form of therapy that can produce real stress reduction and management. We all live busy lives with our stress levels often at a heightened state, and I believe that crocheting can have a significantly positive effect on these levels. The repetitive movement in the creation of stitches, the beautiful textures and happy colors of yarn available, combined with the concentration required to follow a pattern, will often distract our tired minds from the stress of general life and force us to focus on the project at hand. And while

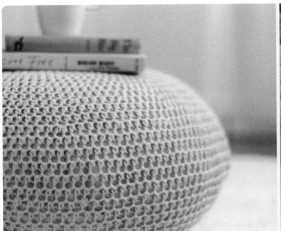
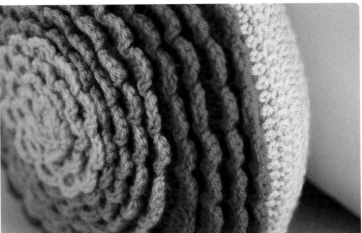

concentrating on a crochet project won't solve life's problems, sometimes it can provide a much-needed break from stress and worry so that the mind can relax and refresh— helping to prepare it for the next day's challenges.

To reap the therapeutic rewards of crafting, I believe a project needs to meet a couple specific requirements: (1) It needs to contain repetitive movements that feel meditative, and (2) it needs to be challenging enough so it distracts and occupies one's mind, but not too difficult as to be frustrating. The very nature of crochet means that it will always meet the first requirement; creating crochet stitches requires a repetition of movement that creates a physical sense of calm. The second requirement depends on the individual; a project that fits the brief for one crocheter may not be suitable for another. For me, a mandala will always be my go-to project for when I'm feeling anxious or uptight, but you should choose a project that will work for you and enjoy the process of creating, not just the end result.

I feel honored to be introducing these gorgeous projects, created by a showcase of talented designers. I don't know about you, but I can't wait to pour a cup of tea, put my feet up, and hook in.

enjoy!
Mandy O'Sullivan
of @craftastherapy on Instagram

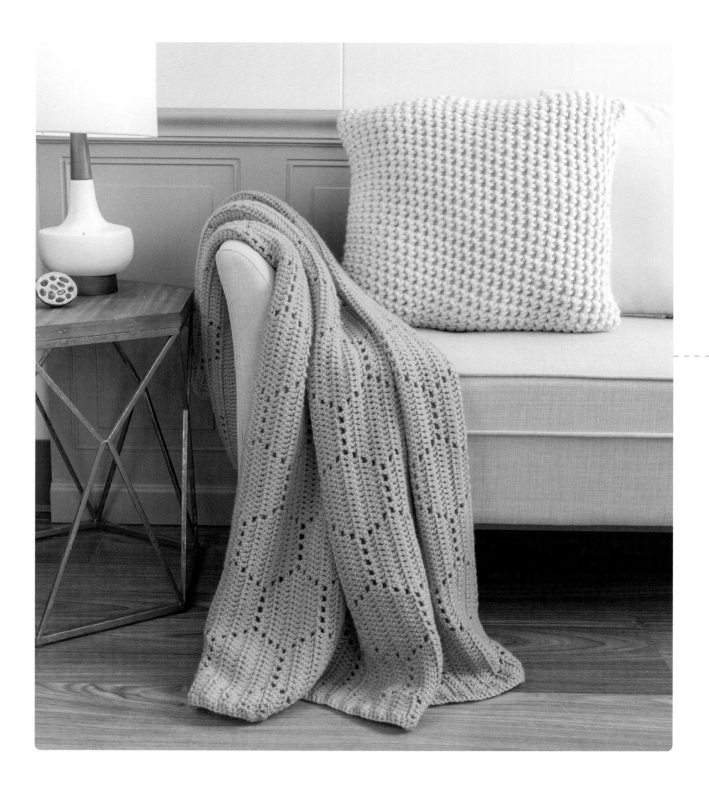

FOR THE
home

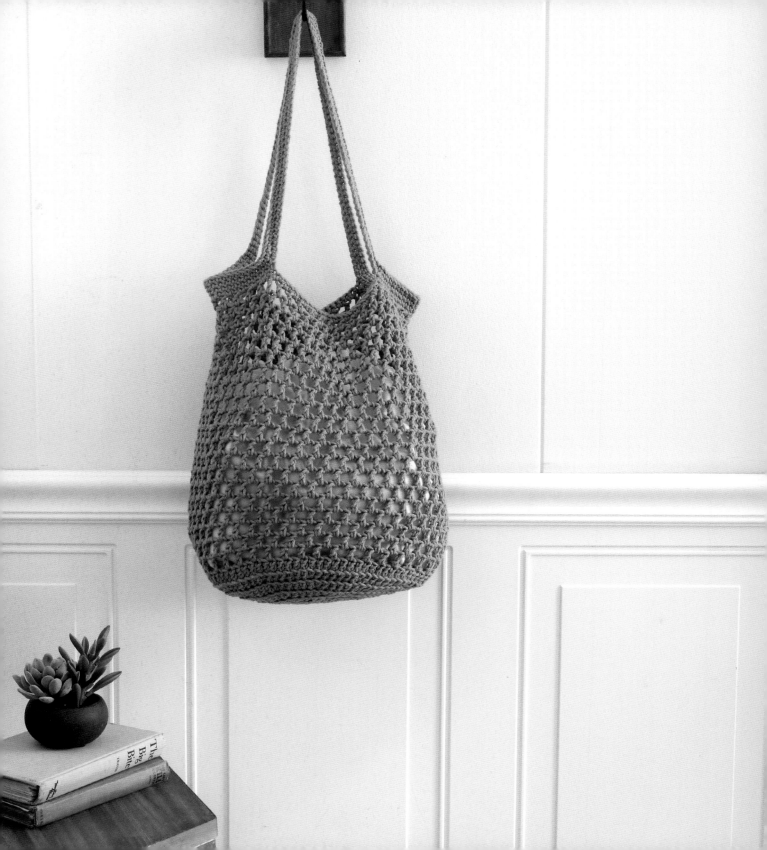

market TOTE

BY KATE DOHN

This crochet tote is the perfect bag for any trip to pick up some groceries. Made with 100% cotton yarn, it has a natural look that also provides durability. Ideal for everyday use, it has a closed circular bottom, open work/filet crochet body, and a double-strap top for easy carrying.

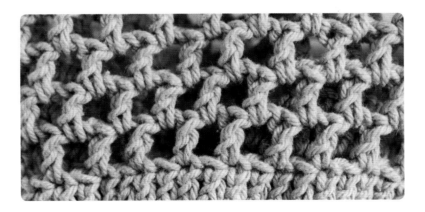

FINISHED SIZE
About 15" (38 cm) wide x 17" (43 cm) tall. Each strap measures 24" (61 cm) long.

YARN
Worsted weight (#4 Medium).

SHOWN HERE: Lion Brand Cotton (100% cotton; 236 yd/216 m; 5 oz/140 g); #760-134 Avocado, 2 balls.

NOTIONS
Yarn needle.

HOOK
Size J-10 (6.0 mm).

GAUGE
First 3 rnds = 4" (10 cm) in diameter. 12 sts and 6 rows = 4" (10 cm) on size J hook. *Adjust hook size if necessary to obtain correct gauge.*

NOTE
• To adjust the size of your finished tote, choose a larger hook and bulkier yarn or smaller hook and thinner yarn. The finished number of sts is denoted at the end of each row.

TOTE

RND 1: Ch 3 (count as dc), 11 dc in 3rd ch from hook, join with a sl st in top of beginning ch-2. (12 dc)

Work in back loops only for Rnds 2–7.

RND 2: Ch 2 (count as dc here and throughout), dc in same sp, 2 dc in each dc around, join with a sl st in top of beginning ch-2. (24 dc)

RND 3: Ch 2, dc in same sp, dc in next dc, *2 dc in next dc, dc in next dc; rep from * around, join with a sl st in top of beginning ch-2. (36 dc)

RND 4: Ch 2, dc in same sp, dc in each of next 2 dc, *2 dc in next dc, dc in each of next 2 dc; rep from * around, join with a sl st in top of beginning ch-2. (48 dc)

RND 5: Ch 2, dc in same sp, dc in each of next 3 dc, *2 dc in next dc, dc in each of next 3 dc; rep from * around, join with a sl st in top of beginning ch-2. (60 dc)

RND 6: Ch 2, dc in same sp, dc in each of next 4 dc, *2 dc in next dc, dc in each of next 4 dc; rep from * around, join with a sl st in top of beginning ch-2. (72 dc)

RND 7: Ch 2, dc in same sp, dc in each of next 5 dc, *2 dc in next dc, dc in each of next 5 dc; rep from * around, join with a sl st in top of beginning ch-2. (84 dc)

RND 8: Ch 2, working in both the back loop of each dc and the back horizontal loop of the same dc, dc in each dc around, join with a sl st in top of beginning ch-2. (84 dc)

RND 9: Working in both loops of sts, ch 4 (count as dc, ch 2 here and throughout), skip next dc, *dc in next dc, ch 2, skip next dc; rep from * around, join with a sl st in second ch of beginning ch-4. (42 dc; 42 ch-2 sps)

RND 10: Ch 3 (count as dc, ch 1 here and throughout), *dc in next ch-2 sp, ch 2; rep from * around, dc in last ch 2 sp, ch 1, join with a sl st in second ch of beginning ch-3. (43 dc; 2 ch-1 sps; 41 ch-2 sp)

RND 11: Ch 4, skip next ch-1 sp, *dc in next ch-2 sp, ch 2; rep from * around, skip last ch-1 sp, join with a sl st in second ch of beginning ch-4. (42 dc; 42 ch-2 sps)

RNDS 12–16: Rep Rnds 10–11 twice; then rep Rnd 10 once.

RND 17: Ch 4, skip next ch-1 sp, *dc in next ch-2 sp, ch 1, [dc in next ch-sp, ch 2] 8 times; rep from * around to last 3 sps, [dc in next ch sp, ch 2] twice, skip next ch-1 sp, join with a sl st in second ch of beginning ch-4. (42 dc; 4 ch-1 sps; 38 ch-2 sps)

RND 18: Ch 3, *dc in next ch-2 sp, ch 1, [dc in next ch-sp, ch 2] 7 times; rep from * around to last 5 sps, dc in next ch-sp, ch 1, [dc in next ch sp, ch 2] 4 times, dc in next ch-sp, ch 1, join with a sl st in second ch of beginning ch-3. (43 dc; 7 ch-1 sps; 36 ch-2 sps)

RND 19: Ch 4, skip next ch-1 sp, *dc in next ch-sp, ch 1, [dc in next ch sp, ch 2] 7 times; rep from * around to last ch-2 sp, dc in next ch sp, ch 2, skip next ch-1 sp, join with a sl st in second ch of beginning ch-4. (42 dc; 5 ch-1 sps; 37 ch-2 sps)

RND 20: Ch 3, *dc in next ch-2 sp, ch 1, [dc in next ch-sp, ch 2] 6 times; rep from * around to last 7 sps, dc in next ch-sp, ch 1, [dc in next ch sp, ch 2] 5 times, dc in next ch-sp, ch 1, join with a sl st in second ch of beginning ch-3. (43 dc; 8 ch-1 sps; 35 ch-2 sps)

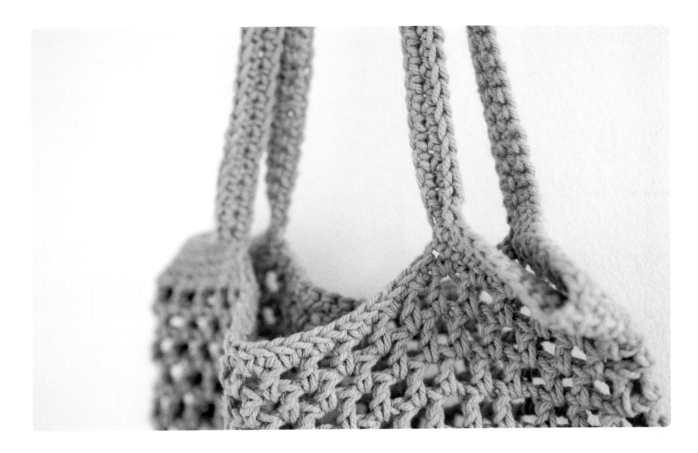

RND 21: Ch 4, skip next ch-1 sp, *dc in next ch-sp, ch 1, [dc in next ch sp, ch 2] 5 times; rep from * around to last 6 ch-sp, dc in next ch-sp, ch 1, [dc in next ch sp, ch 2] 4 times, skip next ch-1 sp, join with a sl st in second ch of beginning ch-4. (42 dc; 7 ch-1 sps; 35 ch-2 sps)

RND 22: Ch 3, *dc in next ch-2 sp, ch 1, [dc in next ch-sp, ch 2] 4 times; rep from * around to last 2 sps, [dc in next ch-sp, ch 1] twice, join with a sl st in second ch of beginning ch-3. (43 dc; 11 ch-1 sps; 32 ch-2 sps)

RND 23: Ch 4, skip next ch-1 sp, *dc in next ch-sp, ch 1, [dc in next ch sp, ch 2] 3 times; rep from * around to last 2 ch-sp, dc in next ch-sp, ch 2, skip next ch-1 sp, join with a sl st in second ch of beginning ch-4. (42 dc; 10 ch-1 sps; 32 ch-2 sps)

RND 24: Ch 3, *dc in next ch-2 sp, ch 1, [dc in next ch-sp, ch 2] twice; rep from * around to last 3 sps, dc in next ch-sp, ch 1, dc in next ch-sp, ch 2, dc in next ch-sp, ch 1, join with a sl st in second ch of beginning ch-3. (43 dc; 16 ch-1 sps; 27 ch-2 sps)

RND 25: Ch 4, skip next ch-1 sp, *dc in next ch-sp, ch 1, dc in next ch sp, ch 2; rep from * around to last ch-sp, dc in next ch-sp, ch 2, skip next ch-1 sp, join with a sl st in second ch of beginning ch-4. (42 dc; 20 ch-1 sps; 22 ch-2 sps)

RND 26: Ch 3, *dc in next ch-sp, ch 1; rep from * around, join with a sl st in second ch of beginning ch-3. (43 dc; 43 ch-1 sps)

15

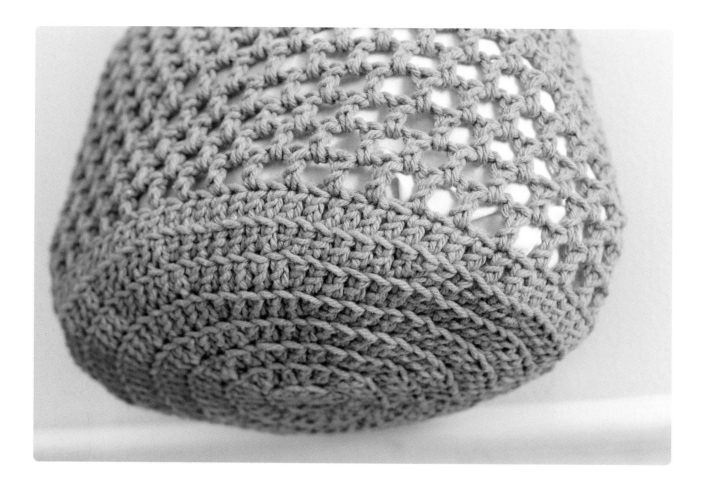

RND 27: Ch 3, skip next ch-1 sp, *dc in next ch-sp, ch 1; rep from * around to last ch-1 sp, skip next ch-1 sp, join with a sl st in second ch of beginning ch-4. (42 dc; 42 ch-1 sps)

RND 28: Rep Rnd 26.

RND 29: Ch 1, sc in each st and ch-sp around, join with a sl st in first sc. (86 sc)

RND 30: Ch 1, sc in each of first 11 sc, ch 80, skip next 21 sc, sc in each of next 22 sc, ch 80, skip next 21 sc, sc in each of next 11 sc, join with a sl st in first sc.

RND 31: Ch 1, sc in each st and ch around, join with a sl st in first sc. (204 sc)

RND 32: Ch 1, sc in each sc around, join with a sl st in first sc. Fasten off.

FINISHING

Weave in ends.

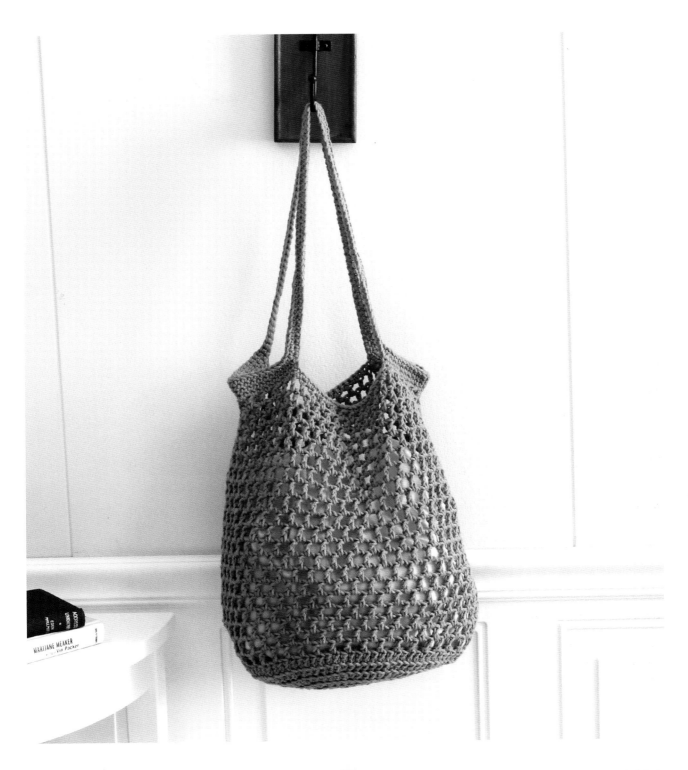

market tote

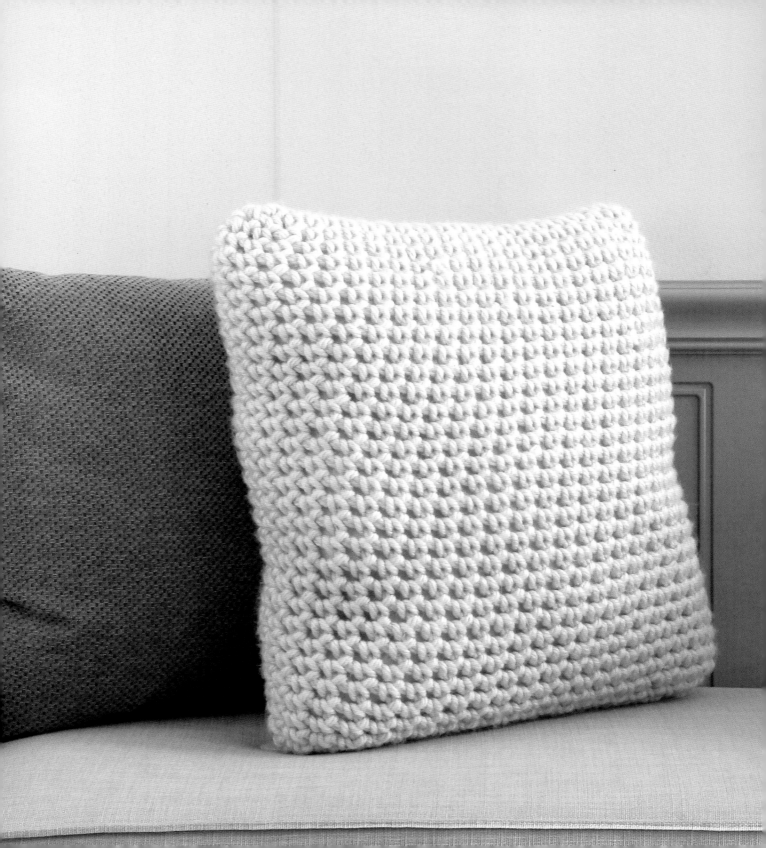

bulky PILLOW

BY CARLA MALCOMB

These beautifully textured pillows are quick and easy to crochet. One-piece construction begins with a chain, followed by seamless rounds of bulky stitches.

FINISHED SIZE

Directions are given for 18" (45.5 cm) pillow. Changes for 20" (51 cm) pillow are in parentheses.

Project shown measures 18" (45.5 cm).

YARN

Jumbo weight (#7 Jumbo).

SHOWN HERE: Lion Brand Hometown USA (100% acrylic; 81 yd/74m; 5 oz/142 g); #098 Houston Cream, 3 (4) skeins.

NOTIONS

Stitch marker; yarn needle; 18 (20)"/45.5 (51) cm square pillow form.

HOOK

Size Q (15.75 mm).

GAUGE

5 sts and 6 rows in sc = 4" (10 cm). *Adjust hook size if necessary to obtain correct gauge.*

NOTES

• Pattern is worked with RS facing, working in a continuous spiral, without joining or turning at the end of each round.

• The foundation ch begins with a tightened slipknot to prevent a gap from forming where stitches are worked in the first chain.

special stitches

Slipknot

Hold yarn at desired length for tail. Cross with main yarn coming from skein to form loop; bring yarn around Rnd to the back and pull through center to make a new loop. Tighten knot and pull main yarn to shorten loop on hook.

Whipstitch

Straight, even seam closure of matching crochet stitchstes, without over tightening.

PILLOW

Leave a 6" (15 cm) tail, ch 22 (24).

RND 1 (RS): Sc in 2nd ch from hook and in each of next 19 (21) ch, 3 sc in last ch, rotate piece to work across opposite side of foundation ch, sc in each of next 19 (21) ch, 3 sc in last ch. (45 [49] sc) Place st marker in last sc just made and move marker up as work progresses.

RNDS 2–29 (32): Sc in each st around.

RND 30 (33): Sc in each st aRnd to marked st. Flatten cover, place marker in st at natural fold on side of pillow cover, sc in each st across to marked st, sl st in next sc. Fasten off, leaving a 60 (72)" (152.5 [183] cm) sewing length.

Weave in all ends except sewing length.

FINISHING

Ease pillow form in cover and carefully align inner corners without stretching or pulling on sts. With open palms of both hands, gently shape and smooth cover evenly over both sides of entire pillow form.

With yarn needle and sewing length, working through both loops of sts, whipstitch front to back across last row of sts.

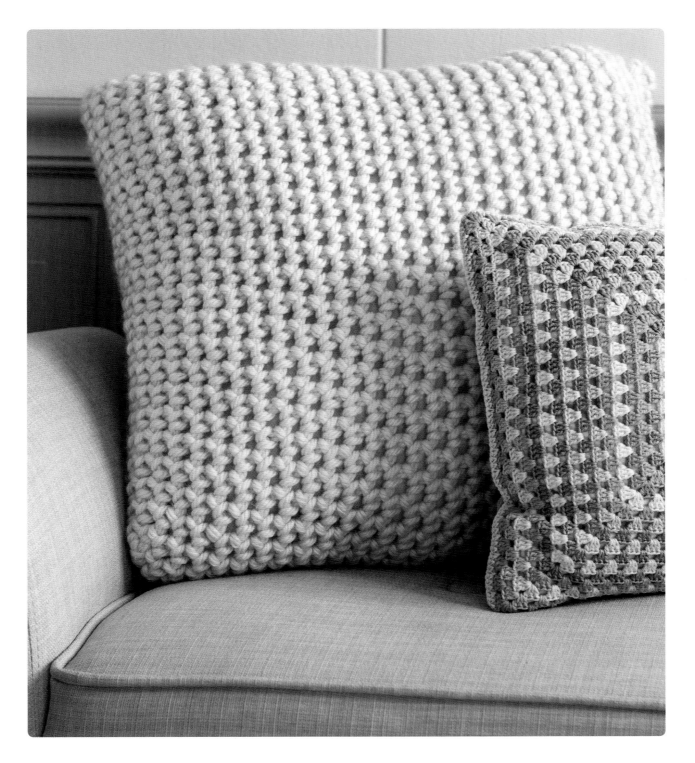

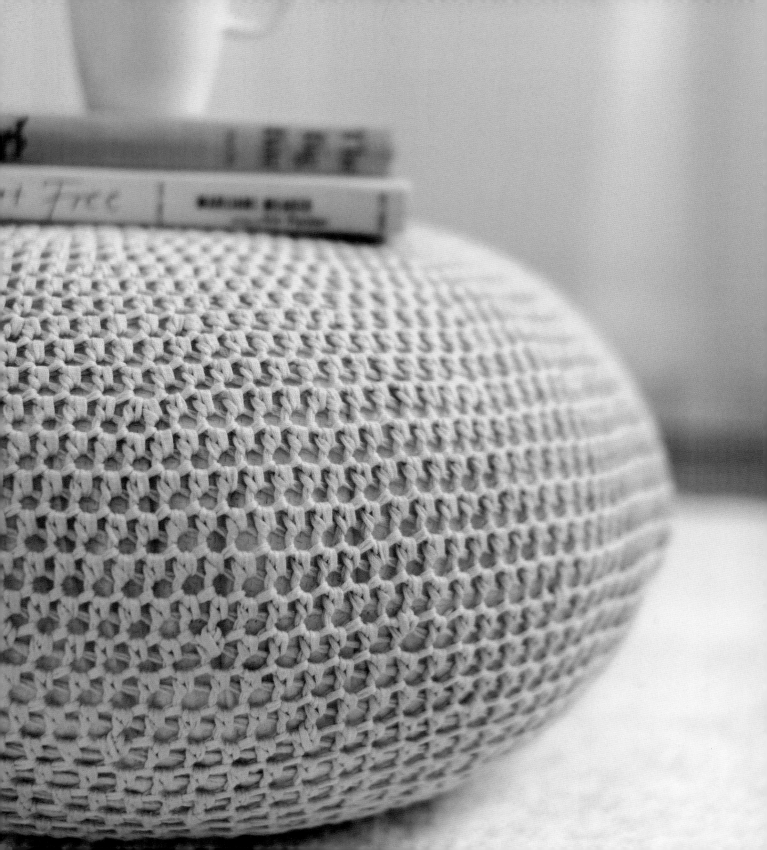

papillon
POUF

BY CARLA MALCOMB

Designed to provide a cozy spot for your feet or your seat, the Papillon Pouf has a graceful silhouette and won't take up much room at all!

FINISHED SIZE
About 10" (25.5 cm) deep x 25 ½" (65 cm) in diameter.

YARN
Bulky weight (#6 Super Bulky).

SHOWN HERE: Rico Fashion Summer (100% cotton; 71 yd/65 m; 1.75 oz/50 g); #005 Silver, 8 balls.

NOTIONS
Yarn needle; pillow insert 10" (25.5 cm) deep x 25½" (65 cm) in diameter.

HOOK
Size L-11 (8 mm).

GAUGE
First 4 rnds = 4½" (11.5 cm) in diameter. *Adjust hook size if necessary to obtain correct gauge.*

POUF

Ch 4, join in a ring with a sl st in first ch.

RND 1: Ch 2 (does not count as a st), 6 hdc in ring, do not join. Work in a spiral placing a marker in first st of rnd, moving marker up as work progresses.

RND 2: 2 hdc in each hdc around. (12 hdc)

RND 3: *Hdc in next st, 2 hdc in next st; rep from * around. (18 hdc)

RND 4: *2 hdc in next st, hdc in next st; rep from * around. (27 hdc)

RND 5: *2 hdc in next st, hdc in next st; rep from * around. (4hdc)

RNDS 6–7: Hdc in each st around.

RND 8: *Hdc in next st, 2 hdc in next st; rep from * around. (6hdc)

RNDS 9–10: Hdc in each st around.

RND 11: *Hdc in each of next 2 sts, 2 hdc in next st; rep from * around. (8hdc)

RNDS 12–13: Hdc in each st around.

RND 14: *Hdc in each of next 3 sts, 2 hdc in next st; rep from * around. (10hdc)

RNDS 15–16: Hdc in each st around.

RND 17: *Hdc in each of next 4 sts, 2 hdc in next st; rep from * around. (12hdc)

RNDS 18–19: Hdc in each st around.

RND 20: *Hdc in each of next 5 sts, 2 hdc in next st; rep from * around. (14hdc)

RNDS 21–25: Hdc in each st around.

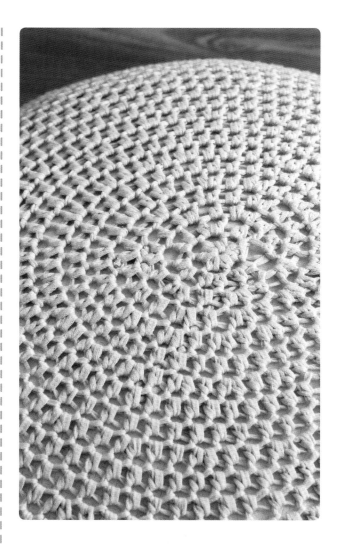

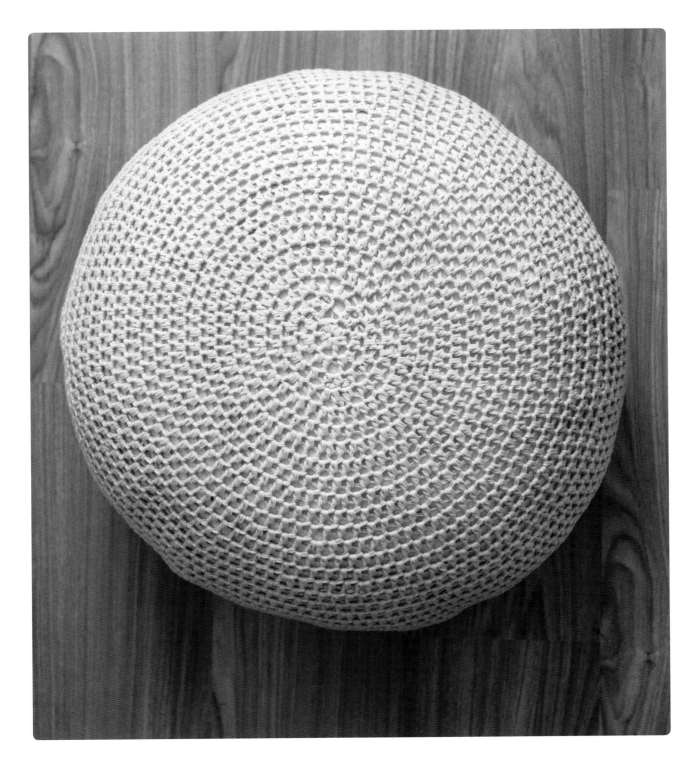

25

papillon pouf

RND 26: *Hdc in each of next 5 sts, hdc2tog worked over next 2 sts; rep from * around. (121 sts)

RNDS 27–28: Hdc in each st around.

RND 29: *Hdc in each of next 4 sts, hdc2tog worked over next 2 sts; rep from * around. (101 sts)

RNDS 30–31: Hdc in each st around.

RND 32: *Hdc in each of next 3 sts, hdc2tog worked over next 2 sts; rep from * around. (81 sts)

RNDS 33–34: Hdc in each st around.

Insert pillow form before finishing cover.

RND 35: *Hdc in each of next 2 sts, hdc2tog worked over next 2 sts; rep from * around. (61 sts)

RNDS 36–37: Hdc in each st around.

RND 38: *Hdc in next st, hdc2tog worked over next 2 sts; rep from * around. (41 sts)

RNDS 39–40: Hdc in each st around.

RND 41: *Hdc in next st, hdc2tog worked over next 2 sts; rep from * around. (27 sts)

RND 42: *Hdc in next st, hdc2tog worked over next 2 sts; rep from * around. (18 sts)

RND 43: *Hdc2tog worked over next 2 sts; rep from * around. (6 sts) Fasten off.

FINISHING

Weave in ends.

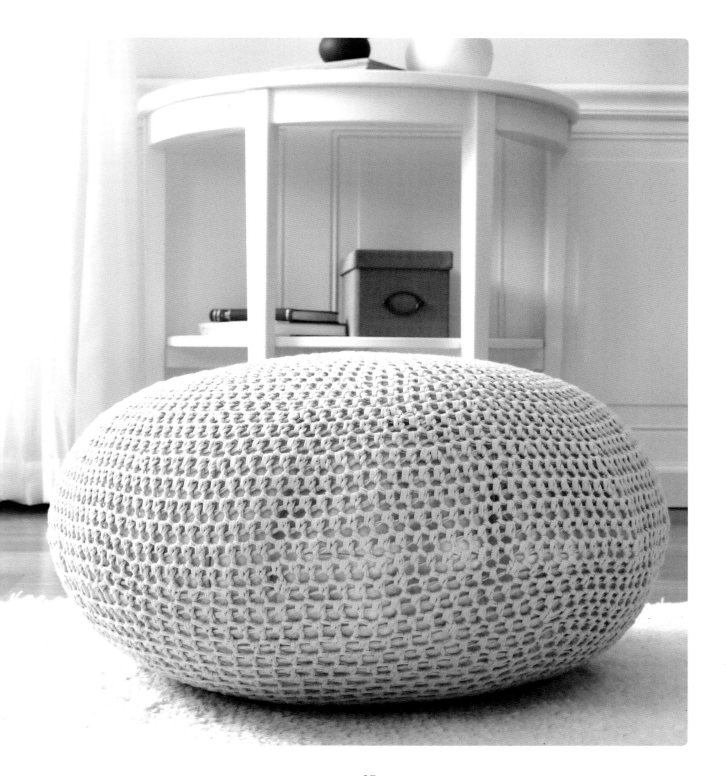

papillon pouf

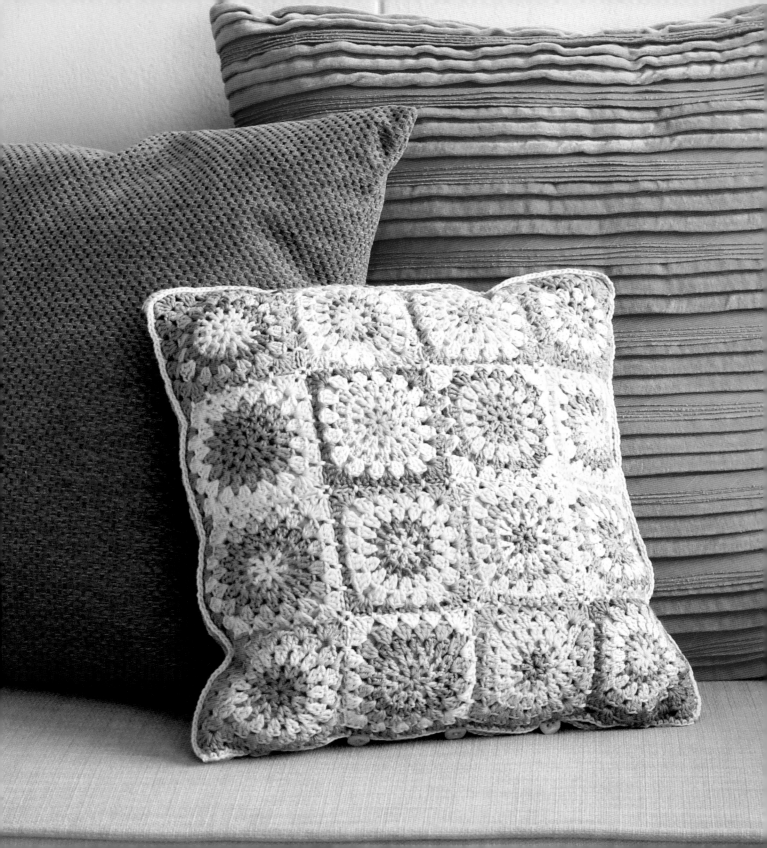

circle square PILLOW

BY ANNEMARIE BENTHEM

There is no better way to chase away a gray day than by making good old-fashioned granny squares! The fun twist to this project is making contrasting patterns for the front and back.

FINISHED SIZE
About 12" x 12" (30.5 x 30.5 cm).

YARN
Fingering weight (#1 Super Fine).

SHOWN HERE:
Rico Fashion Summer (100% cotton; 71 yd/65 m; 1.75 oz/50 g); #005 Silver, 8 balls.

Phildar Phil Coton 3 (100% cotton; 132 yd/121 m; 1.75 oz/50 g). 1 ball each of #3 Ciel (MC), #73 Gold, #59 Menthe, #63 Citron, #57 Guimauve, #42 Piscine, #39 Faience, #8 Mercure, and #70 Melon.

NOTIONS
Yarn needle; pillow insert 12" x 12" (30.5 x 30.5 cm); five ½" (13 mm) buttons (optional).

HOOK
Size 2.50 mm.

GAUGE
First 3 rnds of Back = 2" x 2" (5 x 5 cm). Small square = 3" x 3" (7.5 x 7.5 cm). *Adjust hook size if necessary to obtain correct gauge.*

FRONT

SMALL SQUARE
(MAKE 16 IN RANDOM COLOR SEQUENCES)

With first color, ch 4, join in a ring with a sl st in first ch.

RND 1: Ch 4 (counts as dc, ch 1), [dc, ch 1] 7 times in ring. 1 sl st in 3rd ch of beginning ch-4. Fasten off.

RND 2: With RS facing join next color with sc in any ch-1 sp, ch 3 (sc, ch 3 count as dc, ch 1), dc in the same sp, ch 1, *(dc, ch 1, dc) in next ch-1 sp, ch 1; rep from * around, join with a sl st in 2nd ch of beginning ch-3. Fasten off.

RND 3: With RS facing join next color with sc in any ch-1 sp, ch 2 (sc, ch 2 count as dc here and throughout), dc in the same sp, ch 1, (2 dc, ch 1) in each ch-1 sp around, join with a sl st in 2nd ch of beginning ch-3. Fasten off.

RND 4: With RS facing join next color with sc in any ch-1 sp, ch 2, 2 dc in same sp, ch 2 (corner sp), *(3 dc, ch 1) in each of next 3 ch-1 sps**, 3 dc in next ch-1 sp, ch 2; rep from * around, ending last rep at **, join with a sl st in 2nd ch of beginning ch-3. Fasten off.

ASSEMBLE FRONT

JOINING ROW: With RS of 2 Small Squares facing, working through double thickness, join MC with a sl st in right-hand corner sp, ch 1, sc in corner sp, *sc in each of next 3 dc, sc in next ch-1 sp; rep from * across to next corner. Rep Joining Row to join squares in a larger square, 4 wide, x 4 deep.

FRONT EDGING

Attach the yarn in a corner sp of the large square that's made out of mini squares. The front of the pillow is facing you.

RND 1: With RS facing, join MC with a sc in any corner ch-2 sp, ch 2, (2 dc, ch 2, 3 dc) in same corner sp, ch 1, *(3 dc , ch 1) in each of next 4 ch-1 sps, 3 dc in next joined corner sp, skip the next corner sp twice, (3 dc , ch 1) in each of next 4 ch-1 sps**, (3 dc, ch 2, 3 dc) in next corner sp; rep from * around, ending last rep at **, join with a sl st in top of beginning ch-2. Fasten off.

BACK
(MAKE 1 IN RANDOM COLOR SEQUENCE)

With first color, ch 4, join in a ring with a sl st in first ch.

RND 1: Ch 3, 2 dc in ring, ch 2, (3 dc, ch 2) 3 times in ring, join with a sl st in top of beginning ch-3. (4 ch-2 sps) Fasten off.

RND 2: With RS facing, join next color with sc in any ch-2 sp, ch 2, (2 dc, ch 2, 3 dc) in same sp, ch ch 1, (3 dc, ch 2, 3 dc) in each ch-2-sp around, join with a sl st in top of beginning ch-2. Fasten off.

RND 3: With RS facing, join next color with sc in any ch-2 sp, ch 2, (2 dc, ch 2, 3 dc) in same sp (corner), ch 1, 3 dc in the next ch-1-sp, ch 1**, (3 dc, ch 2, 3 dc) in next ch-2-sp; rep from * around, ending last rep at **, join with a sl st in top of beginning ch-3. (4 ch-2 corner sps) Fasten off.

RND 4: With RS facing, join next color with sc in any ch-2 sp, ch 2, (2 dc, ch 2, 3 dc) in same sp (corner), (ch 1, 3 dc in the next ch-1-sp) in each of next 2 ch-1 sps, ch 1**, (3 dc, ch 2, 3 dc) in next ch-2-sp; rep from * around, ending last rep at **, join with a sl st in top of beginning ch-3. (4 ch-2 corner sps) Fasten off.

RND 5: With RS facing, join next color with sc in any ch-2 sp, ch 2, (2 dc, ch 2, 3 dc) in same sp (corner), (ch 1, 3 dc in the next ch-1-sp) in each ch-1 sp across to next corner, ch 1**, (3 dc, ch 2, 3 dc) in next ch-2-sp; rep from * around, ending last rep at **, join with a sl st in top of beginning ch-3. (4 ch-2 corner sps) Fasten off.

RNDS 6–21: Rep Rnd 5.

CONTINUE IN PATTERN THROUGH RND 21

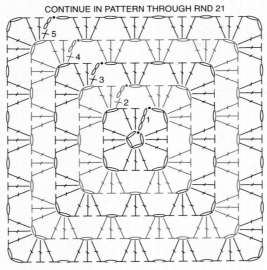

BACK

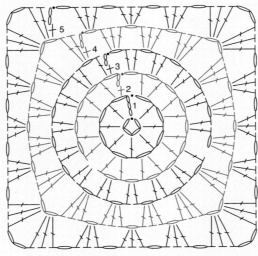

SMALL SQUARE

stitch key

⬭ = chain (ch)

• = slip st (sl st)

✛ = single crochet (sc)

⊤ = double crochet (dc)

ASSEMBLE PILLOW COVER

CLOSED COVER (OPTIONAL)

JOINING RND: With WS of Front and Back facing, join MC with a sl st in any corner ch-2 sp, ch 1, working through double thickness, *work 1 sc in each dc, 1 sc in each ch-1 sp, and (sc, ch 1, sc) in each corner ch-2 sp; rep from * around, inserting pillow form before completing 4th side.

BUTTON CLOSURE (OPTIONAL)

JOINING RND: With WS of Front and Back facing, with Front side facing, join MC with a sl st in any corner ch-2 sp, ch 1, working through double thickness, *work 1 sc in each dc, 1 sc in each ch-1 sp, and (sc, ch 1, sc) in each corner ch-2 sp; rep from * around 3 sides, ending with sc in last corner sp, ch 1, working through Front only, sc in same corner sp, [sc in each of next 3 dc, sc in next ch-1 sp] twice, **ch 4 (button loop), skip next 3 dc, sc in next ch-1 sp, [sc in each of next 3 dc, sc in next ch-1 sp] 3 times; rep from ** 3 times, ch 4, skip next 3 dc, sc in next ch-1 sp, [sc in each of next 3 dc, sc in next ch-1 sp] twice across, ending in beginning corner, rotate to work across Back, working in Back sts only, work 1 sc in each dc and 1 sc in each ch-1 sp across to corner, join with a sl st in first sc in next corner.

FINISHING

Weave in ends. Sew buttons to Back opposite button loops. Insert pillow form. Button Front to Back.

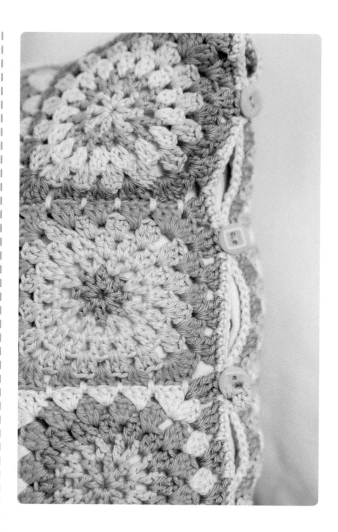

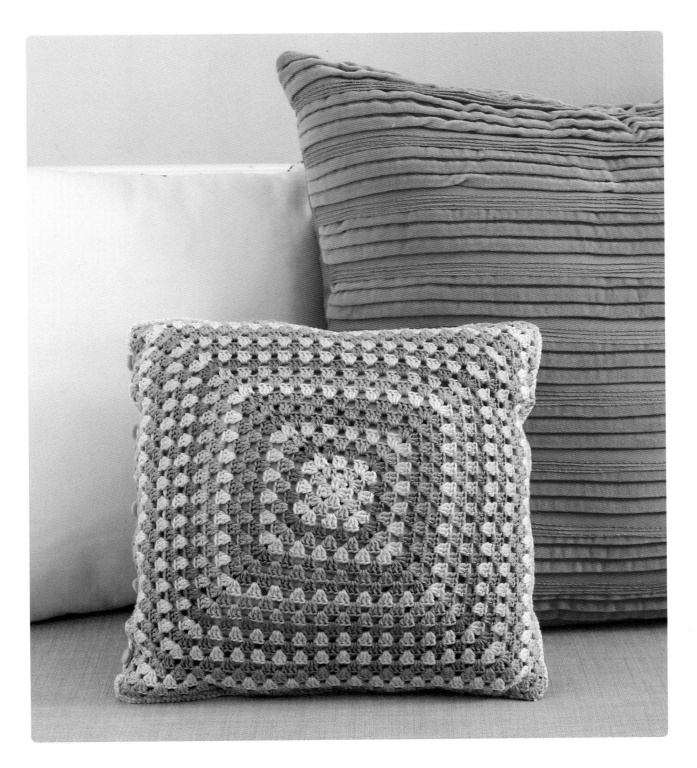

circle square pillow

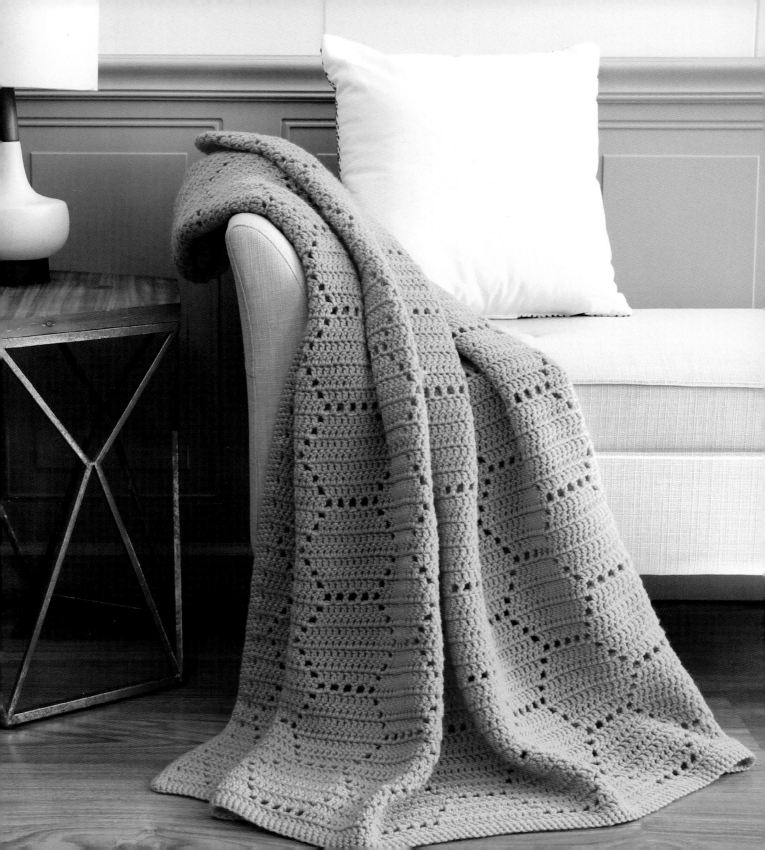

honeycomb BLANKET

BY ANNEMARIE BENTHEM

Cozy up with this soft and comforting blanket. Even busy bees need to have some downtime!

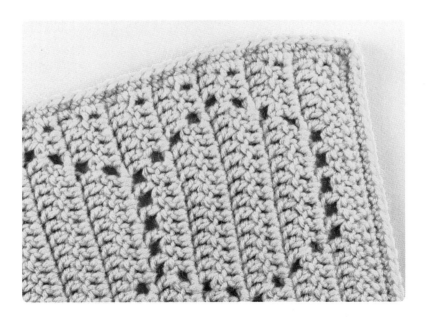

FINISHED SIZE
About 49" x 63" (124.5 x 160 cm).

YARN
Worsted weight (#4 Medium).

SHOWN HERE: Red Heart Super Saver (100% acrylic flecks; 364 yd/333 m; 7 oz/198 g): #321 Gold, 7 skeins.

NOTIONS
Yarn needle.

HOOK
Size J-10 (6.00 mm).

GAUGE
12 sts and 8 rows dc = 4" (10 cm). *Adjust hook size if necessary to obtain correct gauge.*

NOTES
- The last dc of each row should be worked in the top of the ch 3 from the previous row.

- Add or subtract in increments of 24 sts to increase or decrease the size of the blanket.

INSTRUCTIONS

Ch 167.

ROW 1: Dc in 4th ch from hook, dc in each ch across, turn. (165 dc)

ROW 2: Ch 3 (counts as dc here and throughout), dc in each of next 5 dc, *ch 1, skip next st, [dc in next st, ch 1, skip next st] 4 times**, dc in each of next 15 sts; rep from * across, ending last rep at **, dc in each of last 6 sts, turn.

ROW 3: Ch 3, dc in each of next 4 sts, *ch 1, skip next st, dc in each of next 9 sts, ch 1, skip next st**, dc in each of next 13 sts; rep from * across, ending last rep at ** dc in each of last 5 sts, turn.

ROW 4: Ch 3, dc in each of next 3 sts, *ch 1, skip next st**, dc in each of next 11 sts; rep from * from * across, ending last rep at **, dc in each of last 4 sts, turn.

ROW 5: Ch 3, dc in each of next 2 sts, *ch 1, skip next st, dc in each of 13 sts, ch 1, skip next st**, dc in each of next 9 sts; rep from * from * across, ending last rep at **, dc in each of last 3 sts, turn.

ROW 6: Ch 3, dc in next st, *ch 1, skip next st, dc in each of 15 sts**, [ch 1, skip next st, dc in next st] 5 times; rep from * from * across, ending last rep at **, ch 1, skip next st, dc in each of last 2 sts, turn.

ROW 7: Rep Row 5.

ROW 8: Rep Row 4.

ROW 9: Rep Row 3.

ROWS 10–106: Rep Rows 2–9 (12 times), then rep Row 2 once.

ROW 107: Ch 3, dc in each st and sp across.

BORDER

RND 1: Ch 1, sc evenly around, working 3 sc in each corner, join with a sl st in first sc. Fasten off.

FINISHING

Weave in ends.

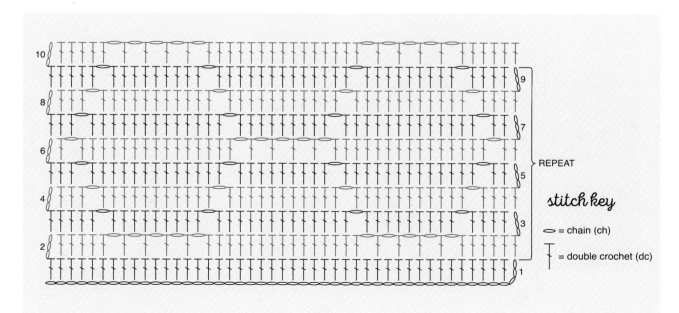

REPEAT

stitch key

⬭ = chain (ch)

Ŧ = double crochet (dc)

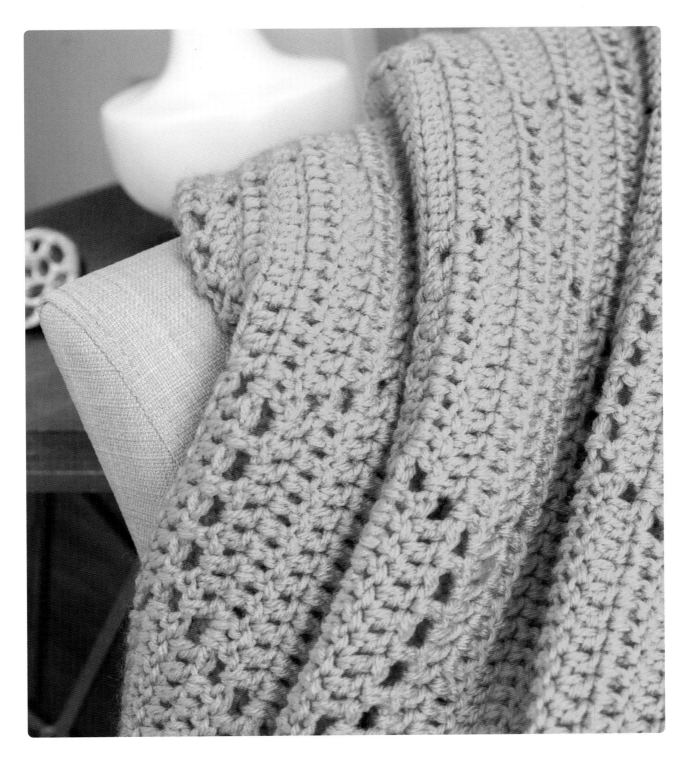

honeycomb blanket

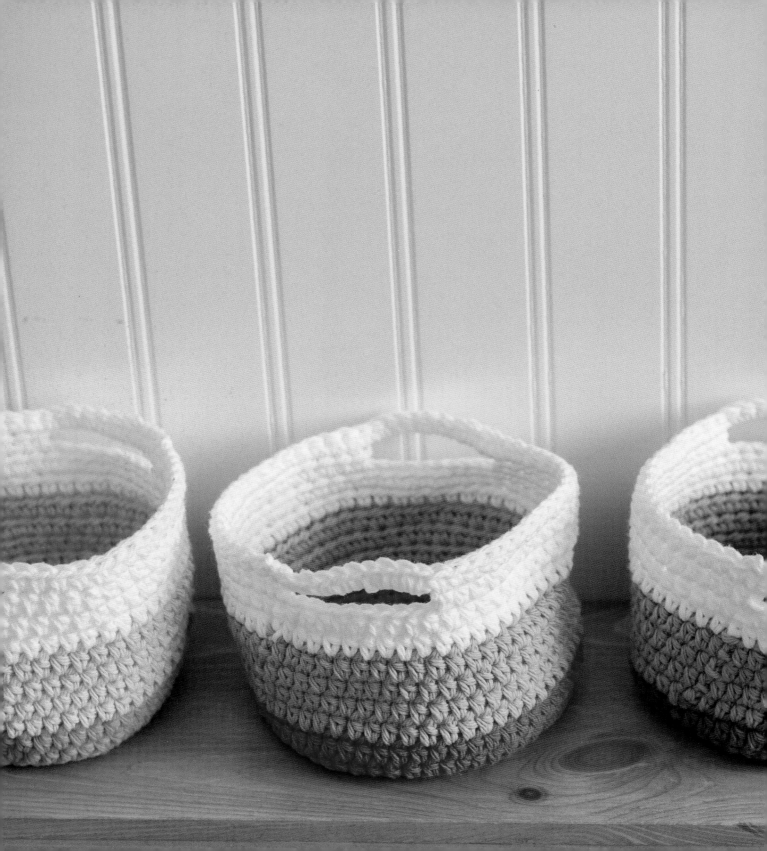

small crochet
BASKET

BY DESIREE HOBSON

This is a fun and quick project. The endless possibilities of color combinations make this the perfect accessory to beautifully display items in any room of your house.

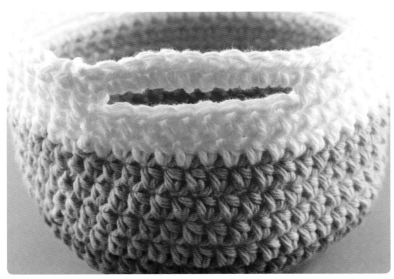

FINISHED SIZE

5" (12.5 cm) in diameter x 4" (10 cm) deep.

YARN

Worsted weight (#4 Medium).

SHOWN HERE: Lily Sugar 'n Cream (100% cotton; 120 yd/109 m; 2.5 oz/70.9 g). Pink Basket: #1740 Hot Pink (A), #46 Rose Pink (B), and #1 White (C), 1 skein each. Orange Basket: #1699 Tangerine (A), #42 Tea Rose (B), and #1 White (C), 1 skein each. Turquoise Basket: #18111 Mod Blue (A), #1215 Robin's Egg (B), and #1 White (C), 1 skein each. Purple Basket: #1318 Black Currant (A), #93 Soft Violet (B), and #1 White (C), 1 skein each.

HOOK

Size G-6 (4.25 mm).

NOTIONS

Yarn needle.

GAUGE

First 5 rnds = 3½" (9 cm) in diameter. *Adjust hook size if necessary to obtain correct gauge.*

BASKET

With A, make an adjustable ring.

RND 1: Ch 1 (does not count as a st here and through-out), 8 hdc in ring, join with a sl st in first hdc. (8 hdc)

RND 2: Ch 1, 2 hdc in first st, 2 hdc in each st around, join with a sl st in first hdc. (16 hdc)

RND 3: Ch 1, 2 hdc in first st, hdc in next st, *2 hdc in next st, hdc in next st; rep from * around, join with a sl st in first hdc. (24 hdc)

RND 4: Ch 1, 2 hdc in first st, hdc in next 2 sts, *2 hdc in next st, hdc in next 2 sts; rep from * around, join with a sl st in first hdc. (32 hdc)

RND 5: Ch 1, 2 hdc in first st, hdc in next 3 sts, *2 hdc in next st, hdc in next 3 sts; rep from * around, join with a sl st in first hdc. (40 hdc)

RND 6: Ch 1, 2 hdc in first st, hdc in next 4 sts, *2 hdc in next st, hdc in next 4 sts; rep from * around, join with a sl st in first hdc. (48 hdc)

RND 7: Ch 1, 2 hdc in first st, hdc in next 5 sts, *2 hdc in next st, hdc in next 5 sts; rep from * around, join with a sl st in first hdc. (56 hdc)

RND 8: Ch 1, hdc in each st around, join with a sl st in first hdc. Fasten off A. Join B.

RNDS 9–12: With B; rep Rnd 8. Fasten off B. Join C.

RNDS 13–14: With C; rep Rnd 8.

RND 15: Ch 1, hdc in each of first 20 sts, ch 8, skip next 8 sts, hdc in each of next 20 sts, ch 8, skip next 8 sts, join with a sl st in first hdc.

RND 16: Ch 1, hdc in each of first 20 sts, 10 sc in next ch-8 sp, sc in each of next 20 sts, 10 sc in next ch-8 sp, join with a sl st in first hdc. Fasten off.

FINISHING

Weave in ends.

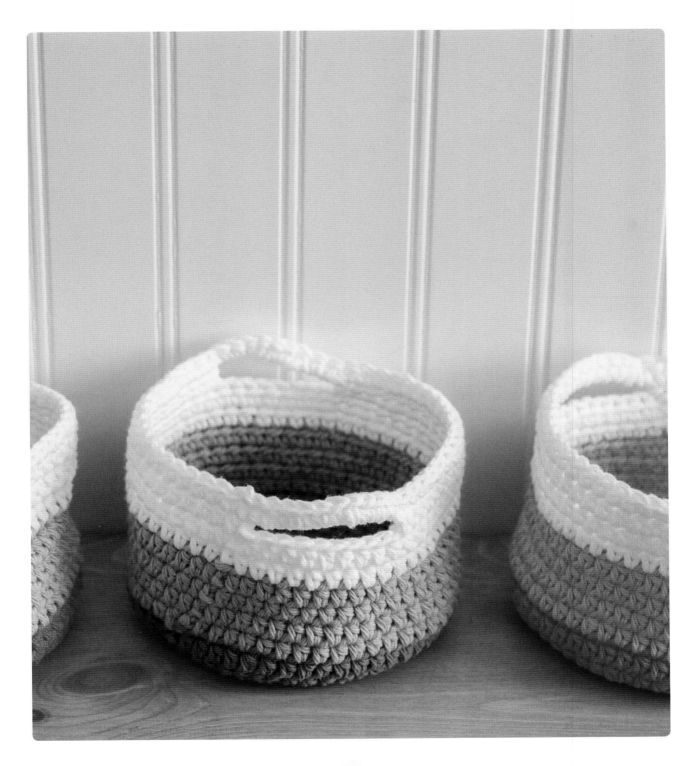

small crochet basket

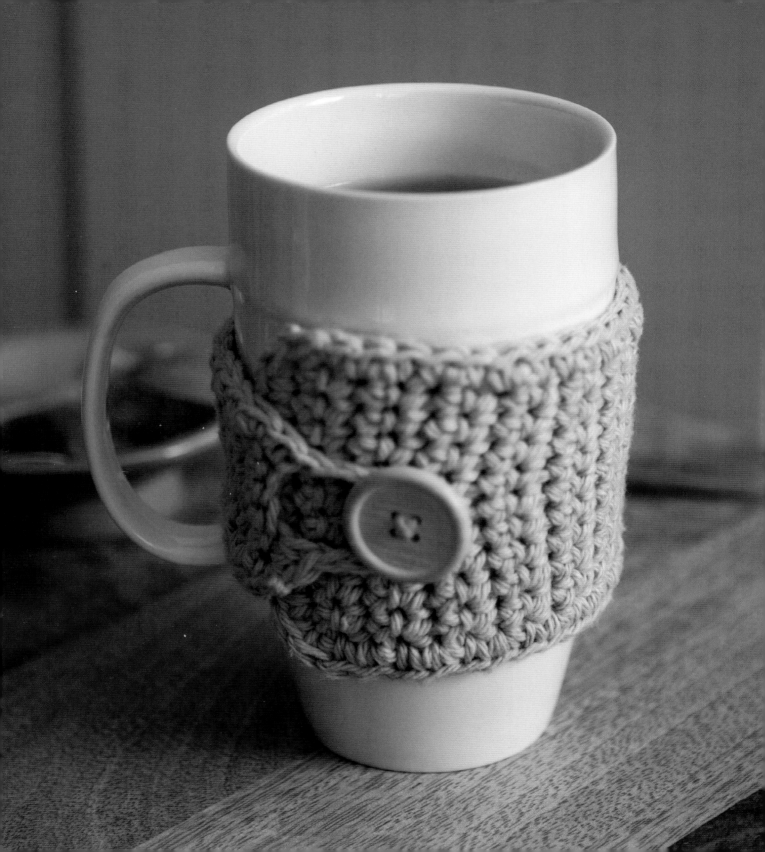

coffee mug
COZY

BY JENNIFER BROWN

Keep your coffee mug all wrapped up with this warm and comfy cozy. Not only will your mug appreciate the homey touch, but your hands will as well! This is a fun and easy project that works up so quickly you'll have gifts made for all your friends and family before you know it.

FINISHED SIZE
10" (25.5 cm) long excluding the button loop x 3½" (9 cm) deep.

YARN
Worsted weight (#4 Medium).

SHOWN HERE: Bernat Handicrafter DeLux Cotton Yarn (100% cotton; 5 oz/142 g; 236 yd/215 m): Seaspray (A), 1 skein.

NOTIONS
Yarn needle; one 1⅛" (3 cm) button.

HOOK
Size H-8 (5 mm).

GAUGE
7 sts and 7 rows sc = 2" (5 cm). *Adjust hook size if necessary to obtain correct gauge.*

NOTE
· This cozy will stretch to fit most standard-size coffee mugs with a circumference of 10–10.5".

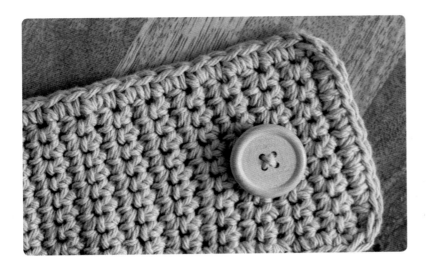

COZY

Ch 11.

ROW 2: Sc in 2nd ch from hook, sc in each ch across, turn. (10 sc)

ROWS 3–28: Ch 1, sc in each sc across, turn.

ROW 29: Ch 1, sl st in each of first 3 sts, ch 1, sc in same st, sc in each of next 5 sts, turn. (6 sc)

ROWS 30–36: Ch 1, sc in each sc across, turn. (6 sc)

ROW 37: Ch 1, sc in each of first 2 sts, ch 8 (for button loop), skip next 2 sts, sc in each of next 2 sts. Do not fasten off.

RND 1: Sc in same corner st, sc evenly across side edge of cozy to foundation ch, working 2 sc in each outside corner, working across foundation edge, sc over foundation ch between each set of 2 sc in Row 1, 2 sc in corner, sc evenly across side edge working 2 sc in outside corner of Row 28, sc corner of Row 36, join with a sl st in first sc of Row 37.

FINISHING

Weave in ends. Sew button on the beginning end of the cozy, about 5–6 rows in from the end.

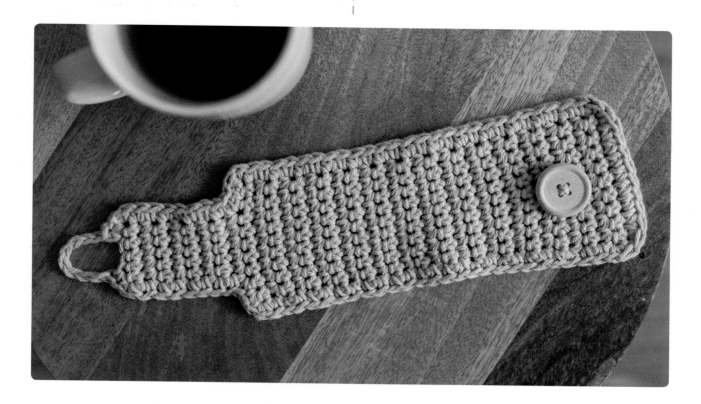

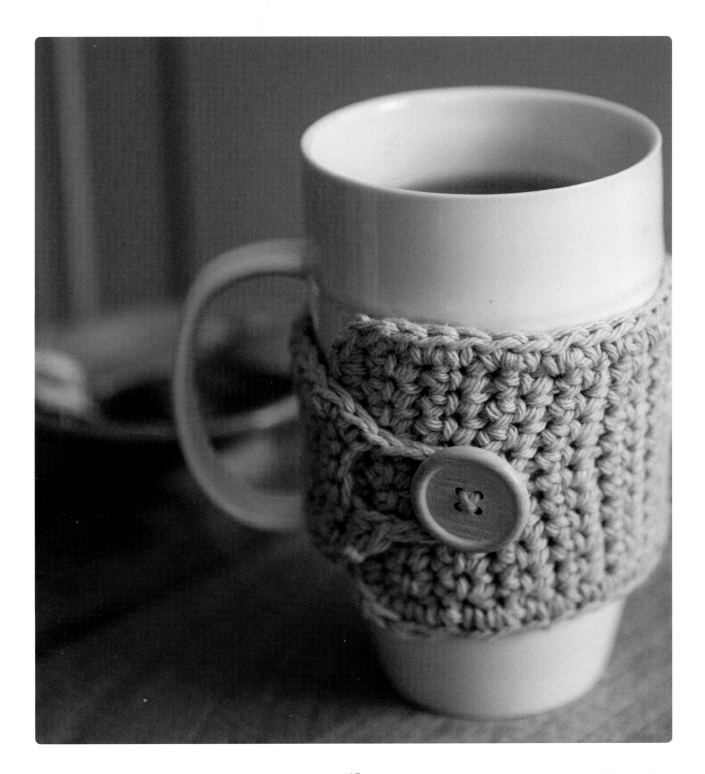

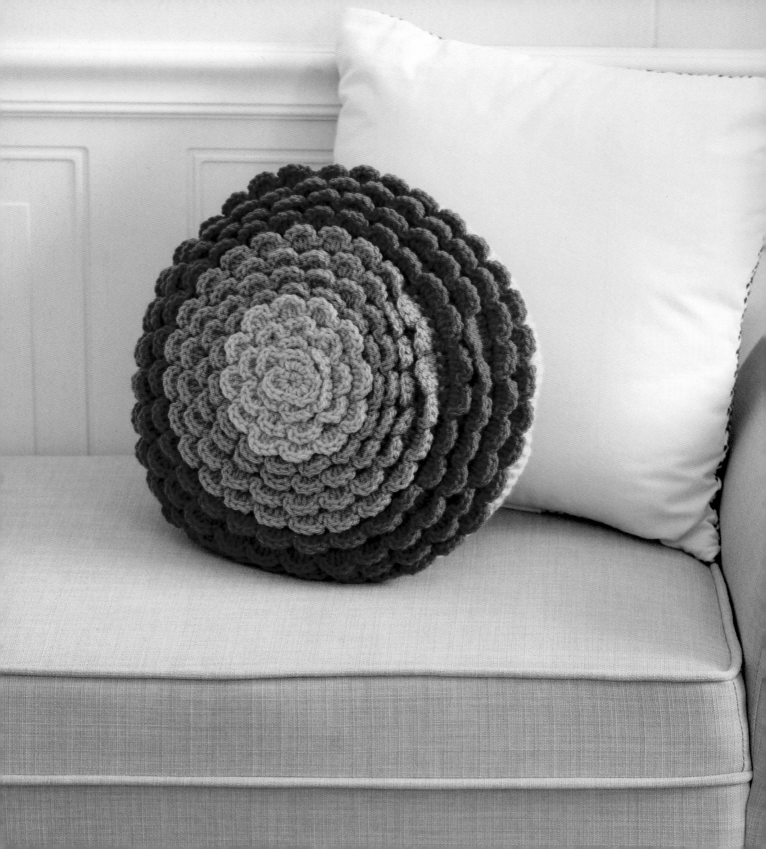

zinnia
PILLOW

BY AMY KLEINPETER

Proving that calming-to-make projects can also be bright and lively, this pillow promises to be a conversation starter.

FINISHED SIZE
About 14" (35.5 cm) in diameter.

YARN
Worsted weight (#4 Medium).

SHOWN HERE: Lion Brand Vanna's Choice (100% acrylic; 170 yd/156 m; 3.5 oz/100 g): #103 Soft Pink (A), #101 Pink (B), and #144 Magenta (C), 1 skein each.

NOTIONS
Yarn needle; 14" (35.5 cm) rnd pillow form.

HOOK
Size I-9 (5.5 mm).

GAUGE
First 3 rnds = 3¾" (9.5 cm) in diameter. *Adjust hook size if necessary to obtain correct gauge.*

NOTE
• This pillow is worked in two separate panels that are sewn together.

FRONT

With A, make an adjustable ring.

RND 1: Ch 2 (counts as dc here and throughout), 8 dc in ring, join with a sl st in top of beginning ch-2. (8 dc). Pull tail to tighten center ring.

RND 2: Ch 2, dc in first st, 2 dc in each st around, join with a sl st in top of beginning ch-2. (18 dc)

RND 3: Ch 2, dc in first st, dc in next st, *2 dc in next st, dc in next st; rep from * around, join with a sl st in top of beginning ch-2. (27 dc)

RND 4: Ch 2, dc in first st, dc in each of next 2 sts, *2 dc in next st, dc in each of next 2 sts; rep from * around, join with a sl st in top of beginning ch-2. (36 dc) Fasten off A, join B.

RND 5: With B. ch 2, dc in first st, dc in each of next 3 sts, *2dc in next st, dc in each of next 3 st; rep from * around, join with a sl st in top of beginning ch-2. (45 dc)

RND 6: Ch 2, dc in first st, *dc in each of next 4 sts**, 2 dc in next st; rep from * around, ending last rep at **, join with a sl st in top of beginning ch-2. (54 dc)

RND 7: Ch 2, dc in first st, dc in each of next 5 sts**, 2 dc in next st; rep from * around, ending last rep at **, join with a sl st in top of beginning ch-2. (63 dc)

RND 8: Ch 2, dc in first st, dc in each of next 6 sts**, 2 dc in next st; rep from * around, ending last rep at **, join with a sl st in top of beginning ch-2. (72 dc) Fasten off B, join C.

RND 9: With C, ch 2, dc in first st, dc in each of next 7 sts**, 2 dc in next st; rep from * around, ending last rep at **, join with a sl st in top of beginning ch-2. (81 dc)

RND 10: Ch 2, dc in first st, dc in each of next 8 sts**, 2 dc in next st; rep from * around, ending last rep at **, join with a sl st in top of beginning ch-2. (90 dc)

RND 11: Ch 2, dc in first st, dc in each of next 9 sts**, 2 dc in next st; rep from * around, ending last rep at **, join with a sl st in top of beginning ch-2. (99 dc)

RND 12: Ch 2, dc in first st, dc in each of next 10 sts**, 2 dc in next st; rep from * around, ending last rep at **, join with a sl st in top of beginning ch-2. (108 dc) Fasten off C, join A.

The circle should now have a diameter of 14" (35.5 cm).

RND 13: With A, ch 2, hdc in first st, *hdc in each of next 11 sts**, 2 hdc in next st; rep from * around, ending last rep at **, join with a sl st in top of beginning ch-2. (117 hdc) Fasten off.

PETALS

RND A: With RS facing, join A aRnd the post of any st in Rnd 1, *ch 2, skip next 2 sts, sl st aRnd the post of next st; rep from * around, working last sl st aRnd post of first st of Rnd 1.

RND B: (Sc, ch 1, 3 dc, ch 1, sc) in each ch-2 sp around, join with a sl st in first sc. Fasten off.

Rep Petals Rnds A and B around Rnds 2–12 of Front, working in matching color yarn.

Note: If needed, using yarn needle and A, tack down the petals of the first 3 rnds to make them lie flat.

BACK

With A only work same as Front through Rnd 11. Fasten off, leaving a 48" sewing length.

FINISHING

With wrong sides together, using sewing length and yarn needle, whip stitch Front to Back, easing in fullness as follows: Every 6th st, work 2 sts from the front into the same st on the back. After sewing approx. 2/3 of the way around, insert pillow form and finish sewing seam. Weave in ends.

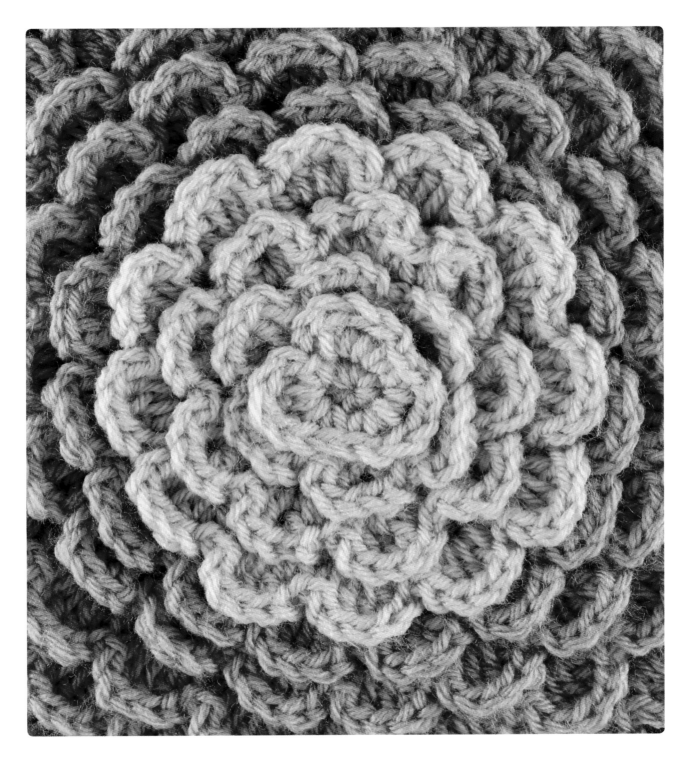

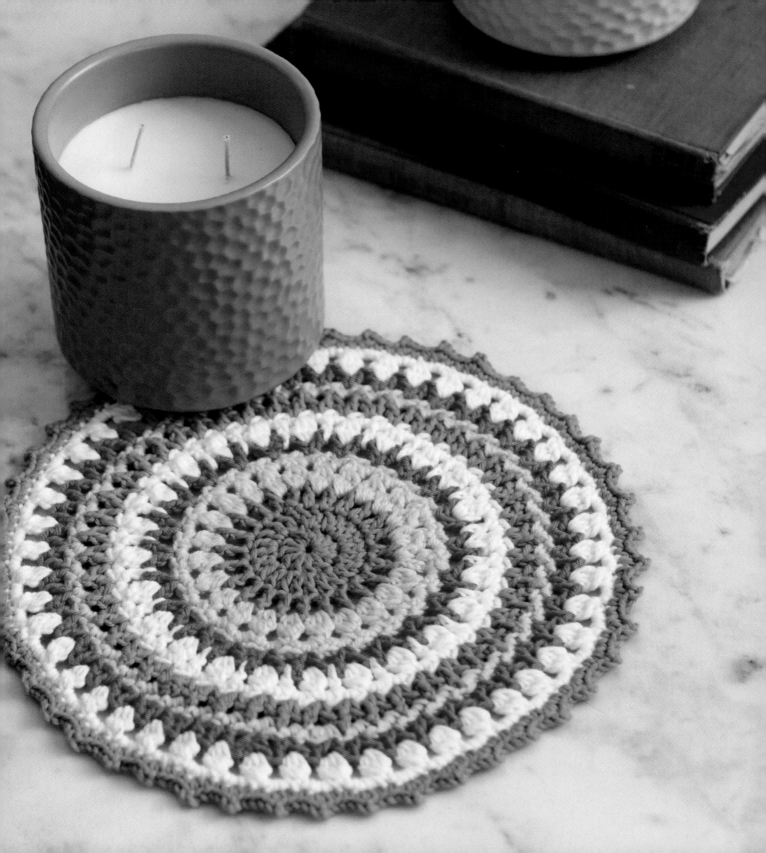

meditative
MANDALA

BY MANDY O'SULLIVAN

The rounds of color hold a promise of blissful, meditative crochet work, and the end result will add a touch of joy to your day!

FINISHED SIZE
About 14" (35.5 cm) in diameter.

YARN
Sport weight (#2 Fine).

SHOWN HERE: Patons Cotton Blend 8 ply (50% cotton/50% acrylic; 103 yd/94 m; 1.75 oz/50 g): #17 Aqua (A), #6 Yellow (B), #25 Flamingo (C), #1 White (D), 1 skein each.

NOTIONS
Yarn needle; scissors.

HOOK
Size G-6 (4 mm).

GAUGE
First 4 rnds = 4" (10 cm) in diameter. *Adjust hook size if necessary to obtain correct gauge.*

special stitches

2-double crochet cluster (2-dc cl)

[Yarn over, insert hook in st or sp, yarn over and pull up loop, yarn over and draw through 2 loops on hook] twice in same st or sp, yarn over and draw through all 3 loops on hook.

3-double crochet cluster (3-dc cl)

[Yarn over, insert hook in st or sp, yarn over and pull up loop, yarn over and draw through 2 loops on hook] 3 times in same st or sp, yarn over and draw through all 4 loops on hook.

V-stitch (V-st)

(Dc, ch 2, dc) in same st or sp.

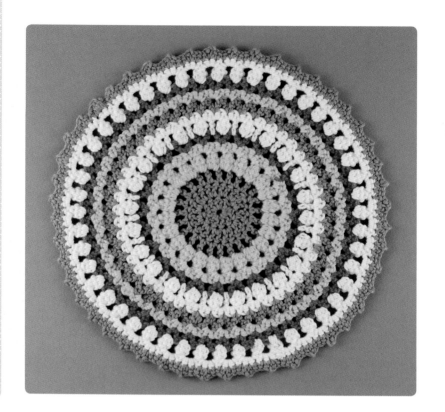

INSTRUCTIONS

With A, make an adjustable ring.

RND 1: Ch 2 (counts as dc here and throughout), work 11 dc in ring, join with a sl st in top of beginning ch-2. (12 dc) Pull tail to tighten center ring.

RND 2: Ch 2, dc in the same st, 2 dc in each dc around, join with a sl st in beginning ch-2. (24 dc)

RND 3: Ch 3 (counts as dc, ch 1 here and throughout), *dc in the next st, ch 1; rep from * around, join with a sl st in 2nd ch of beginning ch-3. Fasten off A. (24 ch-1 sps)

RND 4: With RS facing, join B with a sl st in any ch-1 sp, ch 2, dc2tog (counts as dc3tog), ch 3, *dc3tog in the next ch-1 sp, ch 3; rep from * around, join with a sl st in first dc3tog. (24 ch-3 sps)

RND 5: Sl st in first ch-3 sp, ch 1, 3 sc in each ch-3 sp around, join with a sl st in first sc. (72 sc) Fasten off B.

RND 6: With RS facing, join C with a sl st in 2nd sc of any 3-sc group, ch 4 (counts as dc, ch 2 here and throughout), dc in same st, *skip next 2 sts, V-st in next st; rep from * around, join with a sl st in 3rd ch of beginning ch-4. (24 V-sts) Fasten off C.

RND 7: With RS facing, join D with a sl st in any ch-2 sp, ch 2, dc2tog in the same sp, ch 1, dc in sp between V-sts, ch 1 *dc3tog in the next ch-2 sp, ch 1, dc in sp between V-sts, ch 1; rep from * around, join with a sl st in first dc3tog. (24 dc3tog; 24dc)

RND 8: Sl st in next ch-1 sp, ch 1, 2 sc in each ch-1 sp around, join with a sl st in first sc. Fasten off D.

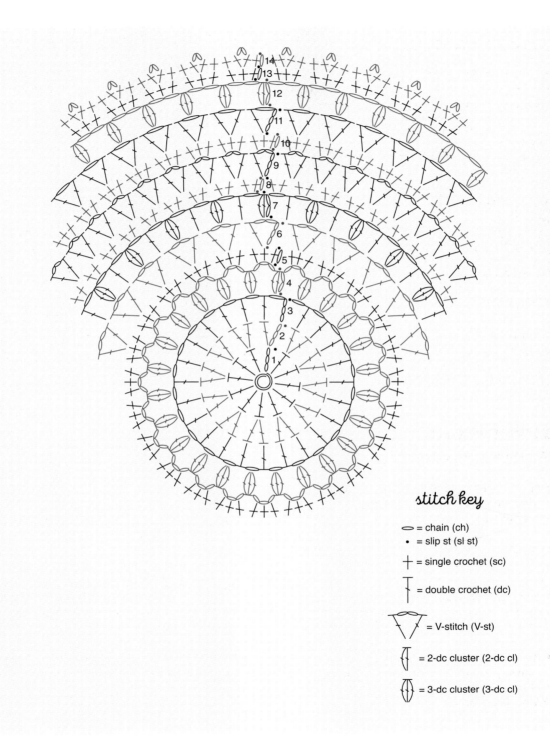

stitch key

◯ = chain (ch)

• = slip st (sl st)

+ = single crochet (sc)

┬ = double crochet (dc)

⋎ = V-stitch (V-st)

⋔ = 2-dc cluster (2-dc cl)

⋔ = 3-dc cluster (3-dc cl)

RND 9: With RS facing, join A with a sl st in sp between 2 groups of 2-sc, ch 4, dc in the same st, *skip next 2 sts, V-st between last skipped and next sc; rep from * around. Fasten off A.

RND 10: With RS facing, join B with a sl st in any ch-2 sp, ch 1, 3 sc in each ch-2 sp around. Fasten off B.

RND 11: With RS facing, join C with a sl st in 2nd sc of any 3-sc grou, ch 3, dc in same st, *skip next 2 sts, (dc, ch 1, dc) in next st; rep from * around, join with a sl st in 2nd ch of beginning ch-3. ,Fasten off C.

RND 12: With RS facing, join D, with a sl st in any ch-1 sp, ch 2, dc2tog in same sp, ch 2, *dc3tog in the next ch-1 sp, ch 2; rep from * around, join with a sl st in first dc3tog.

RND 13: Rep Rnd 10. Fasten off D.

RND 14: With RS facing, join A with a sl st in 2nd sc of any of 3-sc groups, ch 1, (sc, ch 2, sc) in same st, *sc in each of next 2 st**, (sc, ch 2, sc) in next st; rep from * around, ending last rep at **, join with a sl st in first sc. Fasten off.

FINISHING

Weave in ends.

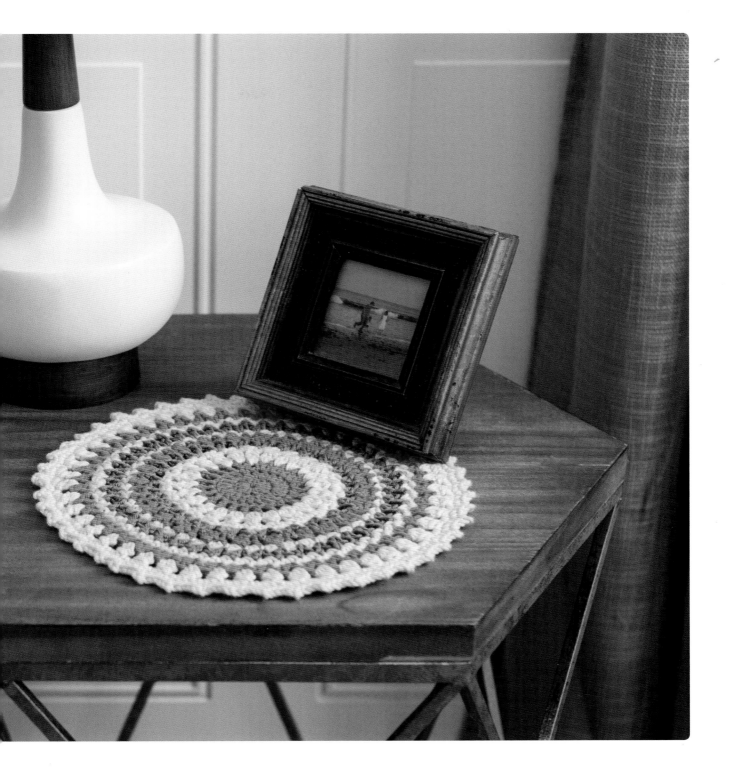

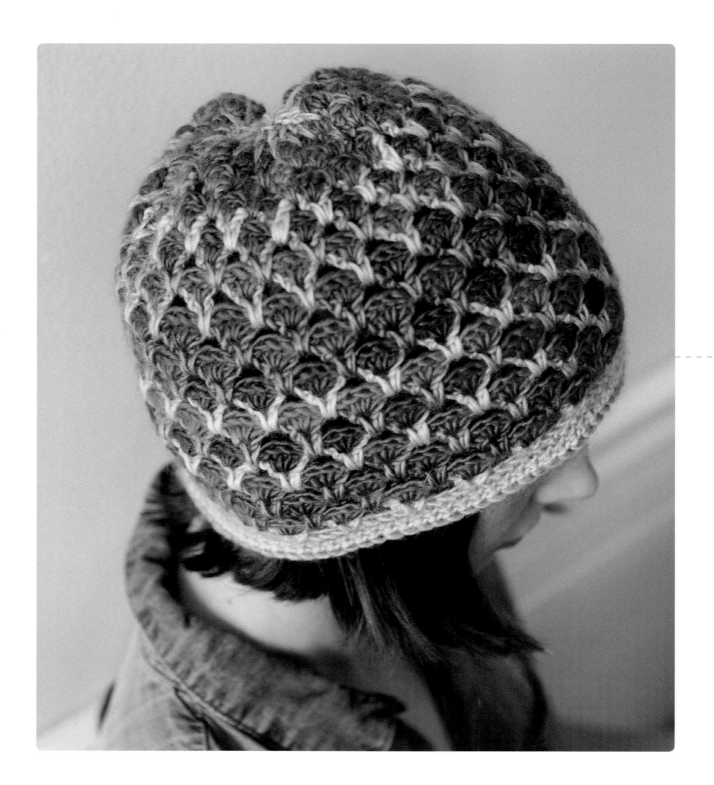

FOR *friends, family, & you!*

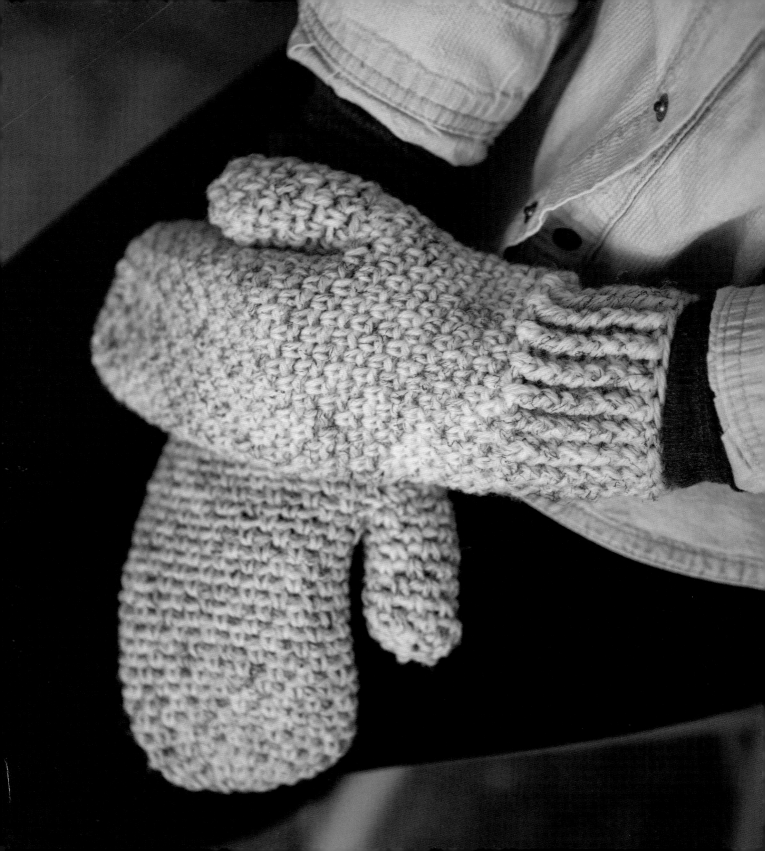

crochet
MITTENS

BY MARTHA MCKEON

You'll want to keep this super quick and easy project for yourself, but it also makes a wonderful gift for family and friends. Attractive textured stitches with good stitch definition and nice recovery, it is easily completed in an evening or two.

FINISHED SIZE

Directions are given for Woman's size Small. Changes for Medium and Large are in parentheses.

Finished measurements: 7 (7½, 8)" (18 [19, 20.5] cm) in circumference x 7½ (8, 8½)" (19 [20.5, 21.5] cm) long.

Project shown measures 7½" (19 cm) in circumference x 8" (20.5 cm) long.

YARN

Worsted weight (#4 Medium).

SHOWN HERE: Patons Cotton Blend 8 ply (50% cotton/50% acrylic; 103 yd/94 m; 1.75 oz/50 g); #17 Aqua (A), #6 Yellow (B), #25 Flamingo (C), #1 White (D), 1 skein each.

SHOWN HERE: Lion Brand Wool-Ease (86% acrylic/10% wool/4% rayon; 197 yd/180 m; 3 oz/85 g): #402 Wheat, 1 skein.

NOTIONS

Yarn needle; stitch marker.

HOOK

Size J-10 (6 mm).

GAUGE

17 sts and 18 rows = 4" (10 cm) in body pattern. *Adjust hook size if necessary to obtain correct gauge.*

NOTES

• Pattern is worked from top to bottom in continuous spiral rounds.

special stitches

Front post double crochet (FPdc)

Yarn over, insert hook from right to left; from front to back, around the post of next dc, yarn over, draw yarn through, [yarn over, draw yarn through 2 loops on hook] twice.

BODY

Ch 3, join in a ring with a sl st in first ch.

RND 1: Ch 1, work 7 (8, 9) sc in ring, do not join. Work in a spiral, marking beginning of each rnd and moving marker up as work progresses. (7 [8, 9] sc)

RND 2: (Sc, ch 1) in each sc around. (7 [8, 9] ch-1 sps)

RND 3: (Sc, ch 1) in each st around. (14 [16, 18] ch-1 sps)

RND 4: (Sc, ch 1) in each ch-1 sp around.

Rep Rnd 4 until piece measures 4½ (5, 5½)" (11.5 [12.5, 14] cm) from beginning.

THUMB OPENING

RND 5: Sc in next ch-1 sp, ch 9, skip next 3 sts, sc in next ch-1 sp, ch 1, (sc, ch 1) in each ch-1 sp around.

RND 6: Working in ch-9, *sc in next ch, ch 1, skip next ch; rep from * 3 times, sc in next ch, ch 1, skip next sc, (sc, ch 1) in each ch-1 sp around. (18 ch-1 sps).

RND 7: (Sc, ch 1) in each ch-1 sp around.

Rep Rnd 7 until piece measures 7½ (8, 8½)" (19 [20.5, 21.5] cm) from beginning.

WRIST CUFF

RND 1: *Sc2tog over next 2 sts; rep from * around. (18 [20, 22] sts)

RND 2: Dc in each st around. (18 [20, 22] dc)

RND 3: FPdc around the post of each dc around until Cuff measures 2¼" (5.5 cm) from beginning, join with a sl st in next st. Fasten off. (18 [20, 22] FPdc)

THUMB

Place marker at inside corner of thumb opening.

RND 1: Join yarn with a sl st in marked st, ch 1, sc in inside corner, sc in next sc, sc in next ch-1 sp, sc in next sc, sc in each of next 9 ch of Thumb Opening, join with a sl st in first sc. (13 sc)

RND 2: *Ch 1, skip next sc, sc in next sc; rep from * around, do not join, work in a spiral as before. (7 ch-1 sps)

RNDS 3–8 (9, 10): (Sc, ch 1) in each ch-1 sp around. (7 ch-1 sps)

RND 9 (10, 11): *Sc2tog over next 2 sts; rep from * around. (7 sts)

RND 10 (11, 12): *Sc2tog over next 2 sts; rep from * 3 times (4 sts), join with a sl st in next st. Fasten off, leaving a sewing length. Turn Mitten and Thumb inside out. With yarn needle, weave sewing length through sts of last rnd of Thumb, gather, and secure.

FINISHING

Weave in ends.

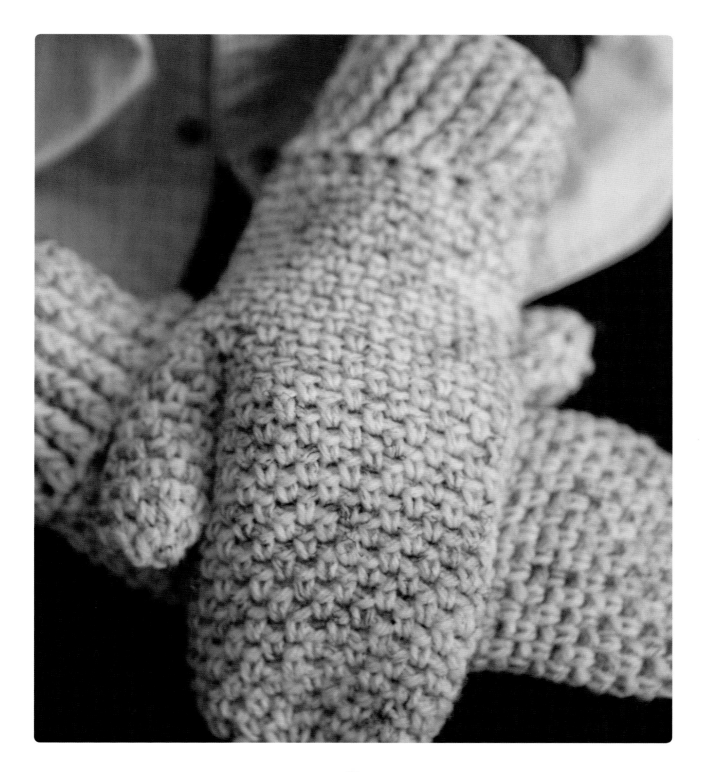

crochet mittens

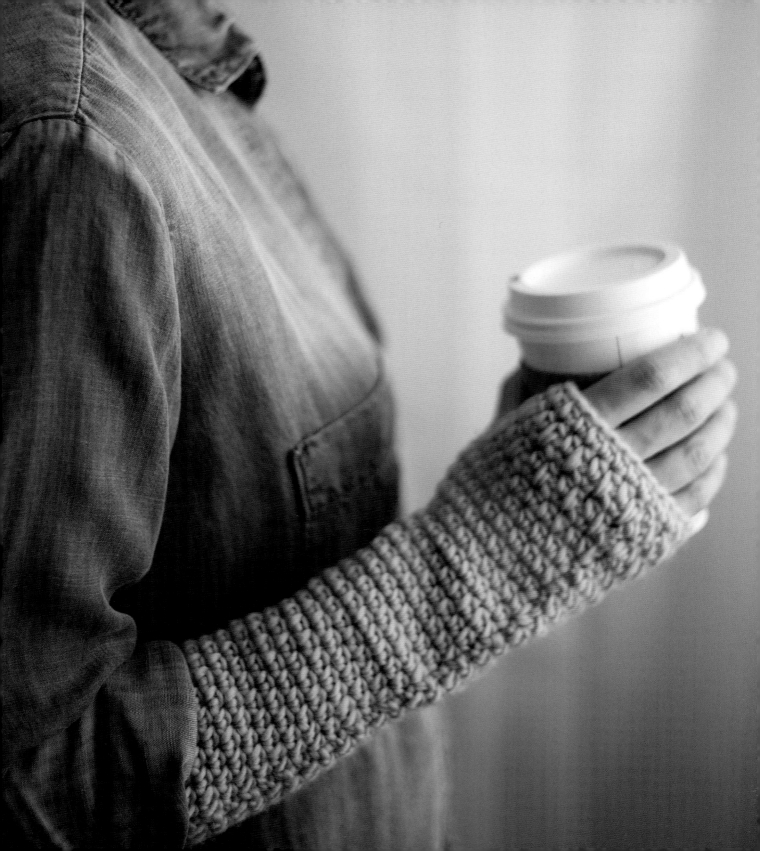

peachy ARM WARMERS

BY JULIE KING

These Peachy Arm Warmers are a great solution for days when it's chilly enough for gloves but you still need to be able to use your fingers! They're constructed in a simple tube that does not increase or decrease in size. Instead, they rely on stretchiness to fit snugly around all parts of your hand and arm and can easily be made in any size to fit you perfectly!

FINISHED SIZE

One size: 8" (20.5 cm) in circumference x 11" (28 cm) long.

Project shown measures 8" (20.5 cm) in circumference x 11" (28 cm) long.

YARN

Worsted weight (#4 Medium).

SHOWN HERE: Loops & Threads Wool to Wash (100% superwash wool; 157 yd/144 m; 3.5 oz/ 100 g): #10 Gray (A) and #1 Pink Passion, 1 skein each.

NOTIONS

Yarn needle.

HOOK

Size H-8 (5 mm).

GAUGE

14 sts and 11 rows in hdc = 4" (10 cm). *Adjust hook size if necessary to obtain correct gauge.*

special stitches

Invisible join

Cut yarn after final st, leaving a short tail, and thread it through your yarn needle. Insert your needle in the first st of that round in the same place that you would insert your hook if you were going to crochet a st there. Pull your needle and yarn through to the back of the st. Insert your needle back in the top of final st. Pull your needle and yarn through to the back of the st and fasten off securely.

INSTRUCTIONS

With A, ch 28 and without twisting ch, join into a circle with a sl st in first ch.

RND 1: Ch 1 (does not count as a st), hdc in each ch around, join with a sl st in first hdc. (28 hdc)

RND 2: Ch 1, skip first st, hdc in each st around to last st, 2 hdc in last st, join with a sl st in first hdc. (28 hdc)

RND 3: Ch 1, hdc in each st around, join with a sl st in first hdc. (28 hdc)

RNDS 4–19: Rep Rnds 2–3 (8 times).

RND 20: Ch 1, skip first st, hdc in each st around to last st, 2 hdc in last st, invisible join with to first hdc. Fasten off A, join B.

RND 21: With B, rep Rnd 3.

RND 22: Rep Rnd 2.

RND 23: Rep Rnd 3.

RND 24: Rep Rnd 20. Fasten off B, join A.

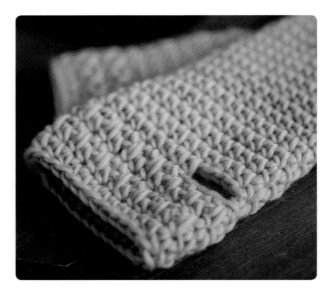

SIZING ADJUSTMENTS

You can easily change the circumference of the arm warmer by chaining more or less than 28 in the beginning. Please ensure that you work an even number of chains to begin. To get the proper size, the starting chain should wrap around your hand and be a little snug at the base of your thumb.

 If you change the size of your starting chain, Rnd 25 will be different for you. A little math is required to determine the values of X and Z in this round.

WHAT IS THE TOTAL NUMBER OF STITCHES IN YOUR STARTING CHAIN?

SUBTRACT 4 =	
DIVIDE IN HALF =	= X
SUBTRACT 1 =	= Z

RND 25 (SEE NOTE ON SIZING ADJUST-MENTS ON PAGE 65): With A, ch 1, hdc in each of the next 11 (Z) sts, ch 4, skip next 4 sts, hdc in each of the next 12 (X) sts, invisible join to first hdc. (24 hdc; 4 ch) Fasten off A, join B.

RND 26: With B, ch 1, sc in first st, ch 1, skip next st, *sc in next st, ch 1, skip next st; rep from * around, invisible join to first sc. (14 ch-1 sps) Fasten off B, join A.

RND 27: With A, ch 2 (counts as hdc here and throughout), *working over next ch-1 sp, hdc in next st 2 rnds below**, hdc in next st in current rnd; rep from * around, ending last rep at **, invisible join to first hdc. (28 hdc) Fasten off A, join B.

RND 28: Rep Rnd 26.

RND 29: With A, ch 2, *working over next ch-1 sp, hdc in next st 2 rnds below**, hdc in next st in current rnd; rep from * around, ending last rep at **, join with a sl st in first hdc.

RND 30: Rep Rnd 20. Fasten off.

FINISHING

Weave in ends.

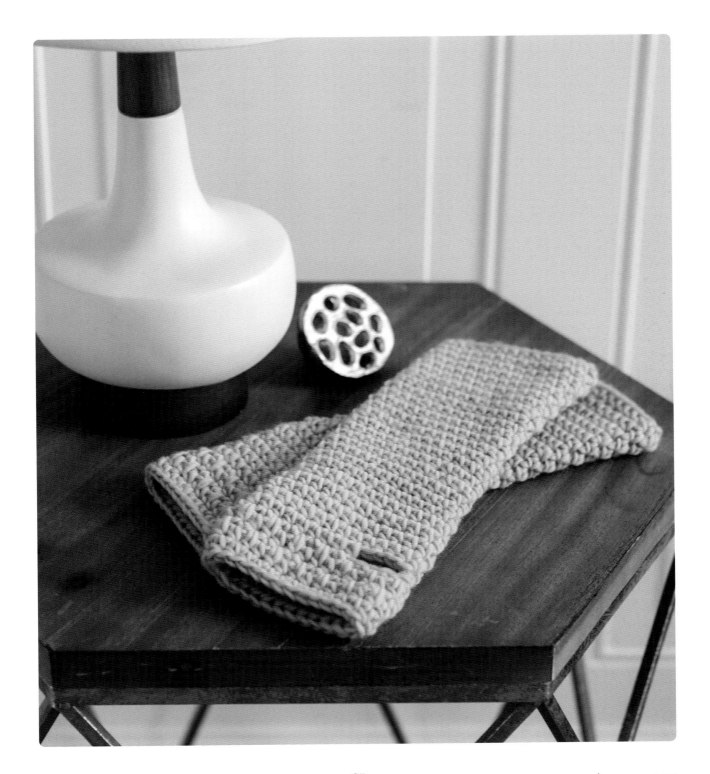

peachy arm warmers

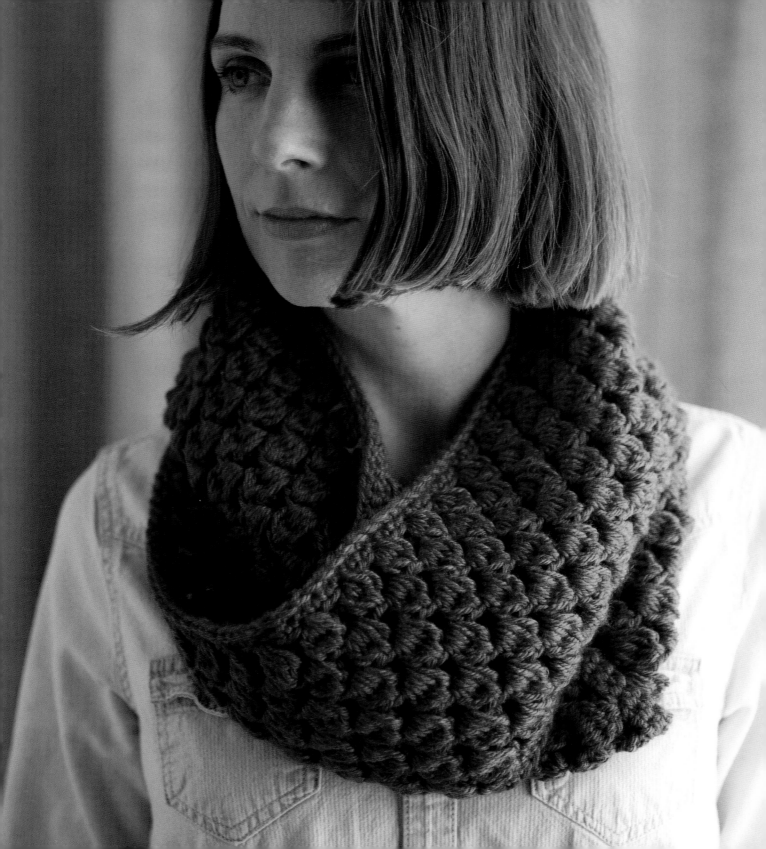

pinecone
INFINITY SCARF

BY JULIE KING

This lovely scarf uses cluster stitches to create a pretty, pinecone-like texture. It's loose fitting and meant to wrap around your neck twice for double the warmth!

FINISHED SIZE

One size: About 63" (160 cm) in circumference x 6" (15 cm) deep.

Project shown measures about 63" (160 cm) in circumference x 6" (15 cm) deep.

YARN

Worsted weight (#4 Medium).

SHOWN HERE: Lion Brand Heartland (100% acrylic; 251 yd/230 m; 5 oz/142 g): #135 Yosemite, 2 skeins.

NOTIONS

Yarn needle.

HOOK

Size J-10 (6 mm).

GAUGE

[Cl, ch 2] 4 times (12 sts) = 4" (10 cm); 4 rows in pattern = 3" (7.5 cm). *Adjust hook size if necessary to obtain correct gauge.*

special stitches

Beginning Cluster (Beg Cl)

Ch 2, [yarn over, insert hook in next st or sp, yarn over, draw up a loop, yarn over, draw through 2 loops on hook] 4 times, yarn over, draw yarn through all 5 loops on hook.

Cluster (Cl)

[Yarn over, insert hook in next st or sp, yarn over, draw up a loop, yarn over, draw through 2 loops on hook] 5 times, yarn over, draw yarn through all 6 loops on hook.

INSTRUCTIONS

Ch 186, join into a circle with a sl st in first ch.

RND 1: Ch 1, sc in each ch around, join with a sl st in first sc. (186 sc)

RND 2: Ch 1, sc in each sc around, join with a sl st in first sc.

RND 3: Beg Cl in same st, ch 2, skip next 2 sts, *Cl in next st, ch 2, skip next 2 sts; rep from * around, join with a sl st in first Cl. (62 Cl; 62 ch-2 sps).

RNDS 4–9: Sl st in next ch-2 sp, Beg Cl in same sp, ch 2, (Cl, ch 2) in each ch-2 sp around, join with a sl st in first Cl.

RND 10: Ch 1, sc in first Cl, 2 sc in next ch-2 sp, *sc in next Cl, 2 sc in next ch-2 sp; rep from * around, join with a sl st in first sc. (186 sc)

RND 11: Ch 1, sc in each sc around, invisible join in first sc. Fasten off.

FINISHING

Weave in ends.

71

pinecone infinity scarf

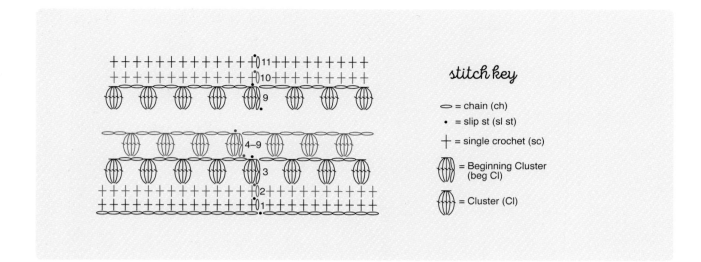

stitch key

\bigcirc = chain (ch)

• = slip st (sl st)

$+$ = single crochet (sc)

\bigcup = Beginning Cluster (beg Cl)

\bigcup = Cluster (Cl)

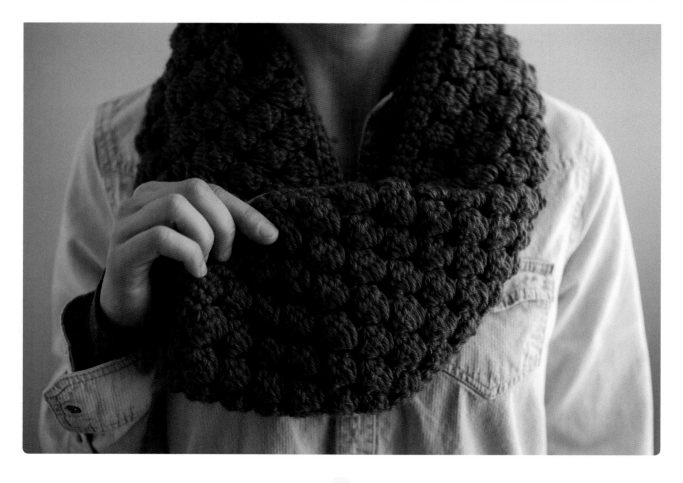

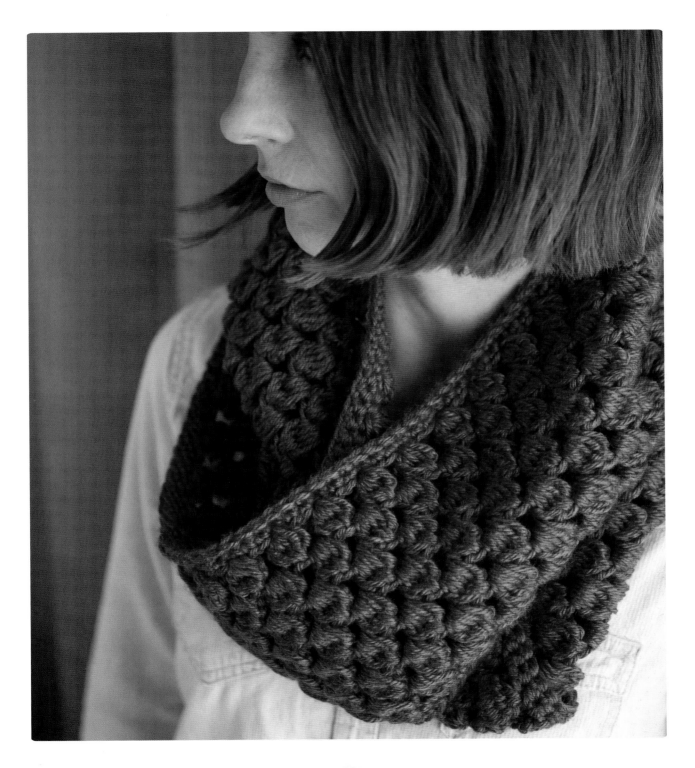

pinecone infinity scarf

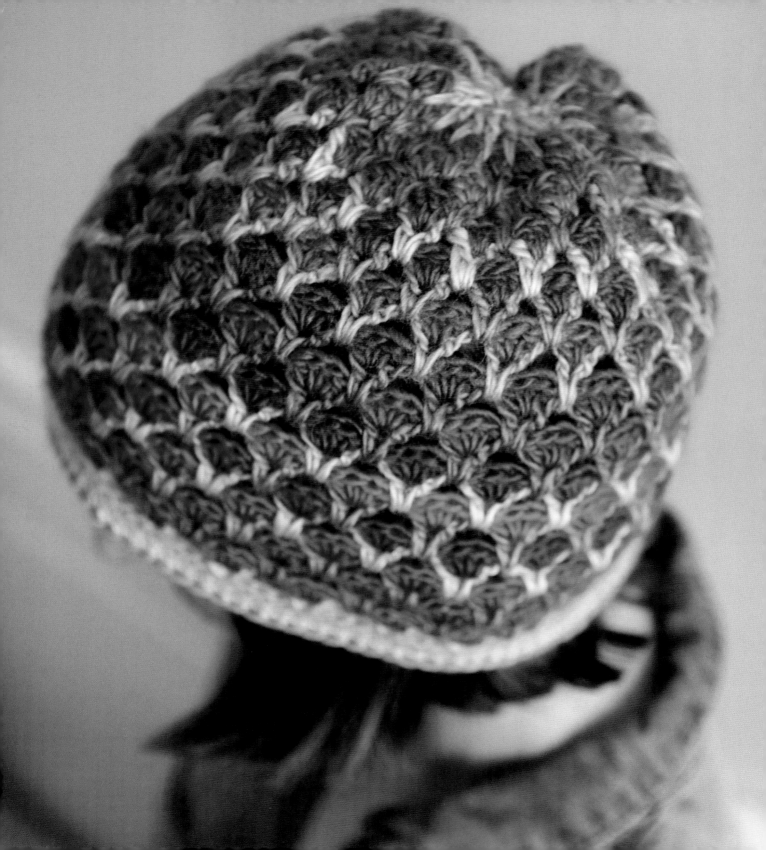

babala HAT

BY TARA MURRAY

Rounds and rounds of luscious color keep you happy and engaged as you're crocheting. The brightly-colored yarn is variegated—only one skein of each colorway is needed!

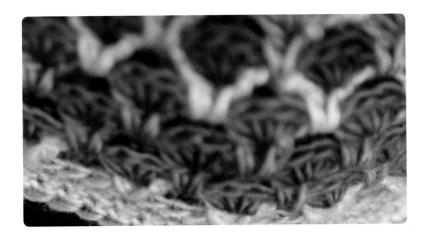

FINISHED SIZE
Hat measures 21" (53.5 cm) in circumference x 8¼" (21 cm) deep.

YARN
Worsted weight (#4 Medium).

SHOWN HERE: Red Heart Boutique Unforgettable (100% acrylic; 270 yd/247 m; 3.5 oz/100 g): #9942 Cappuccino (A) and #3935 Dragonfly, 1 skein each.

NOTIONS
Yarn needle.

HOOK
Size G-6 (4 mm).

GAUGE
16 sts and 12 rows = 4" (10 cm). *Adjust hook size if necessary to obtain correct gauge.*

- Pattern starts at base of the hat and works up to the crown.

- When you change color for each rnd, just drop the working color so that you can pick it up again as you work the pattern.

- If you prefer a slouchy hat, then you will just need to rep Rnds 7–8 a few more times.

- If you would like to make a larger hat (or even a cowl) with this st pattern, then it will be helpful to know that the foundation ch needs to be a multiple of 4 + 1.

- This hat looks best when using two highly contrasting colors. I would choose a dark yarn and a light yarn.

- Boutique Unforgettable is a lighter worsted-weight yarn, so heavier worsted-weight yarns such as Red Heart Super Saver and Lion Brand Vanna's Choice will have a larger gauge.

special stitches

Dc cluster

[Yarn over, insert hook in next st or sp, yarn over and pull up a loop, yarn over, draw yarn through 2 loops on hook] twice in same st or sp, yarn over, draw yarn through 3 loops on hook.

INSTRUCTIONS

With A, ch 88 and without twisting ch, join into a circle with a sl st in first ch.

RND 1: Ch 1, sc in each ch around, join with a sl st to first sc. (88 sc)

RNDS 2–3: Ch 1, sc in each sc around, join with a sl st to first sc.

RND 4: Ch 2 (counts as dc here and throughout), dc in first st, ch 2, skip next 3 sts, *2 dc in next st, ch 2, skip next 3 sts; rep from * around, join with a sl st in top of beg ch-2. (22 ch-2 sps) Drop A to WS to be picked up later.

RND 5: Join B with a sl st in sp between first 2 dc, ch 2, 3 dc in same sp, * 4 dc in sp between next 2 dc; rep from * around, join with a sl st in top of beg ch-2. (88 dc) Drop B, pick up A from row below.

RND 6: With A, *ch 2, working over previous rnd, work 2 dc in next ch-2 sp 2 rnds below; rep from * around, join with a sl st in first ch of beg ch-2, sl st in next ch, sl st in first dc. (22 ch-2 sps) Drop A, pick up B from row below.

RNDS 7–20: Rep Rnds 5–6 (7 times). Drop A, pick up B from row below.

RND 21: Sl st in sp between first 2 dc, ch 2, 2 dc in same sp, *3 dc in sp between next 2 dc; rep from * around, join with a sl st in top of beg ch-2. (66 dc) Drop B, pick up A from row below.

RND 22: With A, *ch 1, working over previous rnd, work 2 dc in next ch-2 sp 2 rnds below; rep from * around, join with a sl st in beg ch-1, sl st in first dc. (22 ch-1 sps)

RNDS 23–26: Rep Rnds 21–22 (twice). Drop A, pick up B from row below.

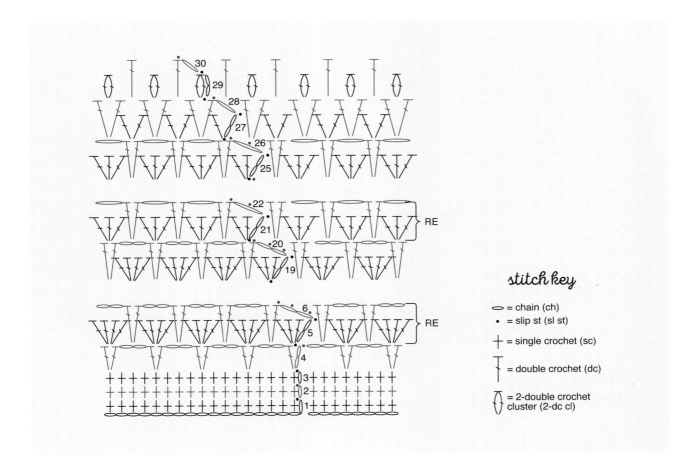

stitch key

◯ = chain (ch)

• = slip st (sl st)

+ = single crochet (sc)

�┬ = double crochet (dc)

⦵ = 2-double crochet cluster (2-dc cl)

RND 27: With B, sl st in sp between first 2 dc, ch 2, work dc in same sp, *work 2 dc in sp between next 2 dc; rep from * around, join with a sl st in top of beg ch-2. (44 dc) Drop B, pick up A from row below.

RND 28: With A, ch 1 (does not count as a st), work 2 dc in ch-1 sp from two rnds down, *working over previous rnd, work 2 dc in next ch-2 sp 2 rnds below; rep from * around, join with a sl st in first dc. (44 dc) Drop A, pick up B from row below.

RND 29: With B, sl st in sp between first dc group, ch 2 (does not count as a st), cluster in same sp, *cluster in sp between next 2 dc; rep from * around, join with a sl st in first cluster. (22 clusters) Drop B, pick up A from row below.

RND 30: With A, ch 1 (does not count as a st), *working over previous rnd, work dc between next 2 dc 2 rnds below; rep from * around, join with a sl st in first dc. (11 dc) Fasten off both colors, leaving a sewing length of A. With yarn needle, weave sewing length through sts in last rnd, gather tightly, and secure.

FINISHING

Weave in ends.

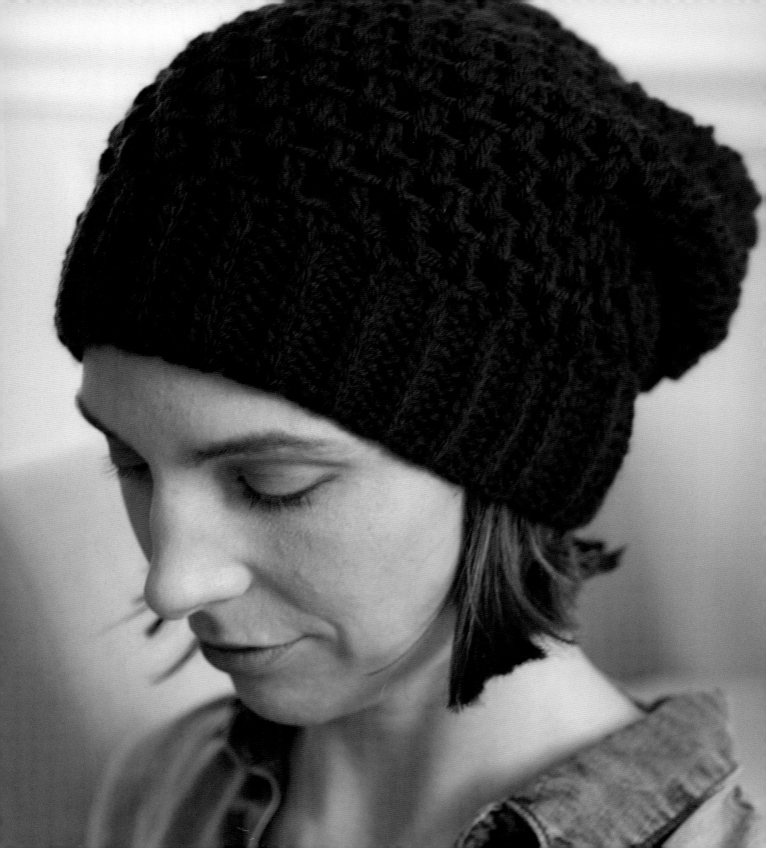

juno slouch HAT

BY JUSTINE WALLEY

Juno is a stylish, slouchy beanie hat pattern featuring a snug ribbed brim and pretty puff stitches. This hat is quick and easy to work up, and its simple style will add flair to any outfit.

FINISHED SIZE
One size fits most: 19" (48.5 cm) in circumference x 10" (25 cm) tall.

YARN
Worsted weight (#4 Medium).

SHOWN HERE: Willow Yarns Burrow (75% acrylic/25% washable wool; 197 yd/180 m; 3.5 oz/100 g): #46 Navy, 1 skein.

NOTIONS
Yarn needle; stitch marker.

HOOKS
Sizes H-8 (5 mm) and J-10 (6 mm).

GAUGE
With smaller hook, 16 sts and 11 rows in hdc = 4" (10 cm). *Adjust hook size if necessary to obtain correct gauge.*

NOTES
• Hat brim is worked lengthwise in rows, with the ends crocheted together to form a band. Hat body is then worked in a spiral from brim to crown and sewn up at the top.

• From Rnd 2 on, this hat is worked in a spiral, without joining rounds. Use a st marker to mark the first st of each rnd.

special stitches

Puff stitch (puff st)

[Yarn over, insert hook in indicated st or sp, yarn over and draw up a loop] twice in same st, yarn over and draw through all 5 loops on hook.

Frontmost loop of half double crochet

Loop on front of indicated hdc.

INSTRUCTIONS

BRIM

With H-8 hook, ch 11.

ROW 1: Hdc in 2nd ch from hook and in each ch across, turn. (10 hdc)

ROWS 2-54: Ch 1 (does not count as a st), hdc in frontmost loop of each hdc across, turn.

JOINING ROW

Ch 1, working through frontmost loops of sts in last row and front loops of sts in Row 1, sl st first row to last row to form a band.

CROWN

RND 1: With larger hook, ch 1, work 60 sc evenly spaced around Joining Row of Brim, join with a sl st in first sc. (60 sc)

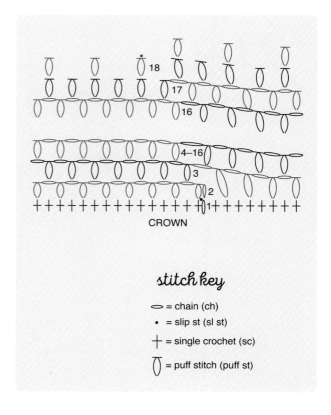

CROWN

stitch key

⬯ = chain (ch)

• = slip st (sl st)

+ = single crochet (sc)

◊ = puff stitch (puff st)

RND 2: Draw up loop on hook, *puff st in next st, ch 1, sk next st; rep from * around, do not join. Work in a spiral placing a marker in first st of rnd, moving marker up as work progresses. (30 puff sts, 30 ch-1 sps)

RNDS 3-16: (Puff st, ch 1) in each ch-1 sp around.

RND 17: Puff st in each ch-1 sp around. (30 puff sts)

RND 18: *Skip next puff st, puff st in next puff st; rep from * around, join with a sl st in next st. (15 puff sts)

Fasten off, leaving a long sewing length. With yarn needle, weave sewing length through sts of last rnd and gather tightly and secure.

FINISHING

Weave in ends.

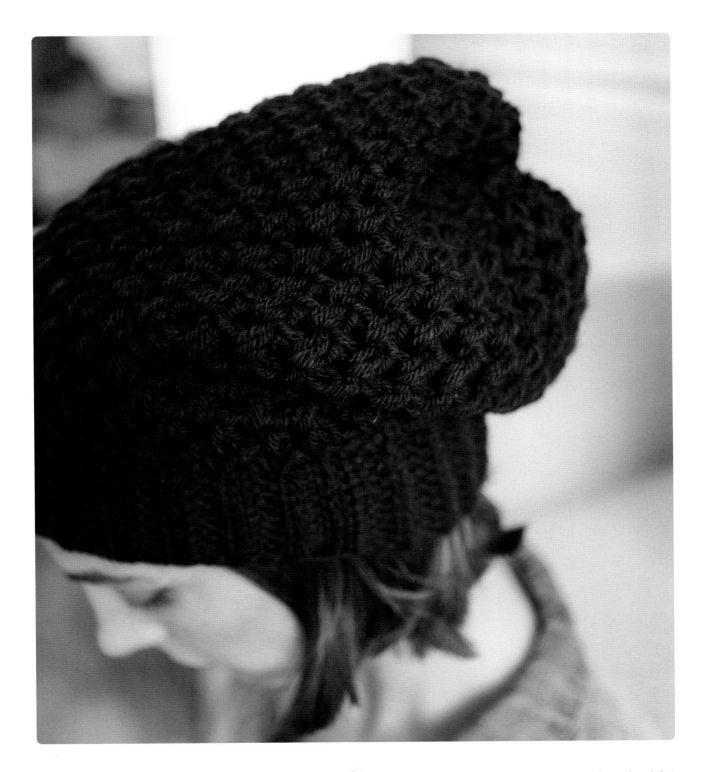

juno slouch hat

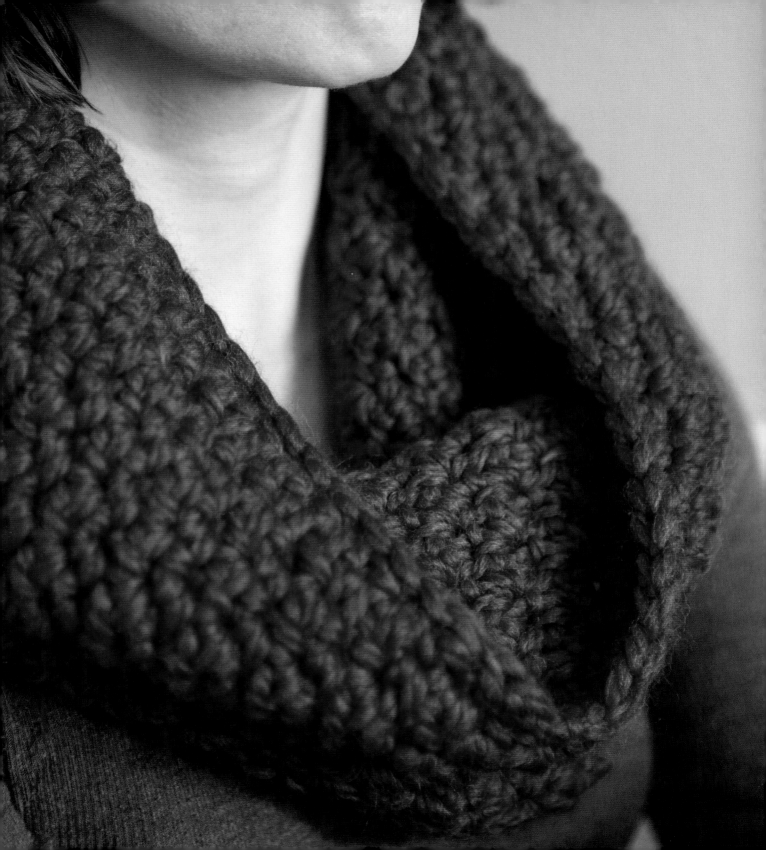

super chunky
COWL

BY ERIN HANSEN

This simple-to-stitch cowl is versatile enough to dress up or down, whether you're hanging at home or getting ready for a night on the town. Make it in all your favorite colors.

FINISHED SIZE

Directions are given for Child's size (3–10 years). Changes for Women's size are in parentheses.

Women's size measures 30" (76 cm) in circumference x 13" (33 cm) deep.

Child's size measures 20" (51 cm) in circumference x 9" (23 cm) deep.

YARN

Bulky weight (#6 Super Bulky).

SHOWN HERE: Loops & Threads Cozy Wool (50% wool/50% acrylic; 90 yd/82 m; 4.5 oz/127 g): 1 (3) skeins.

NOTIONS

Yarn needle.

HOOK

Size N-15 (10 mm).

GAUGE

8 sts and 7 rows = 4" (10 cm). *Adjust hook size if necessary to obtain correct gauge.*

NOTE

• The pattern instructions allow you to make the scarf in any size, using any yarn and hook size. Included are instructions for the two sizes shown above using size 6 super bulky yarn and an N-15 (10 mm) crochet hook. If using a different yarn or hook size, simply follow the instructions until the desired scarf length and width are met, making sure to start with an even number of beginning chains. The scarf is made to form a continuous loop that slips over the head.

HAT

Loosely ch 40 (56) (or desired cowl circumference, working an even number of ch sts) and without twisting ch, join into a circle with a sl st in first ch.

RND 1: Ch 1, sc in first ch, dc in next ch, *sc in next ch, dc in next ch; rep from * around, join with a sl st in first sc. (20 [28] sc; 20 [28] dc)

RND 2: Ch 1, dc in first sc, sc in next dc, *dc in next sc, sc in next dc; rep from * around, join with sl st in first dc. (20 [28] dc; 20 [28] sc)

RND 3: Ch 1, sc in first dc, dc in next sc, *sc in next dc, dc in next sc; rep from * around, join with a sl st in first sc.

Rep Rnds 2–3 until piece measures 9 (13)" (23 [33] cm) from beginning or desired depth. Fasten off.

FINISHING

Weave in ends.

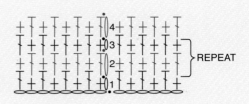

REPEAT

stitch key

⌒ = chain (ch)

• = slip st (sl st)

+ = single crochet (sc)

† = double crochet (dc)

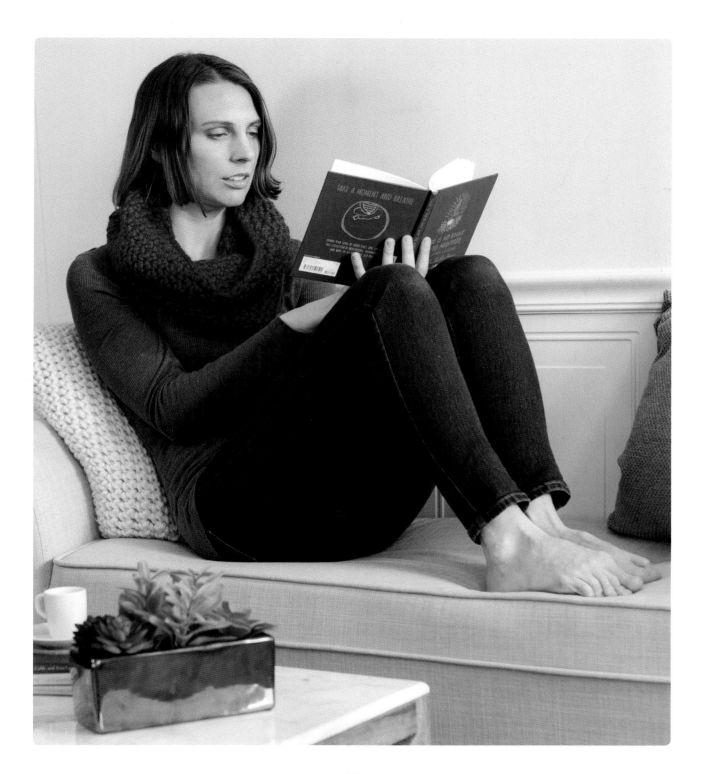

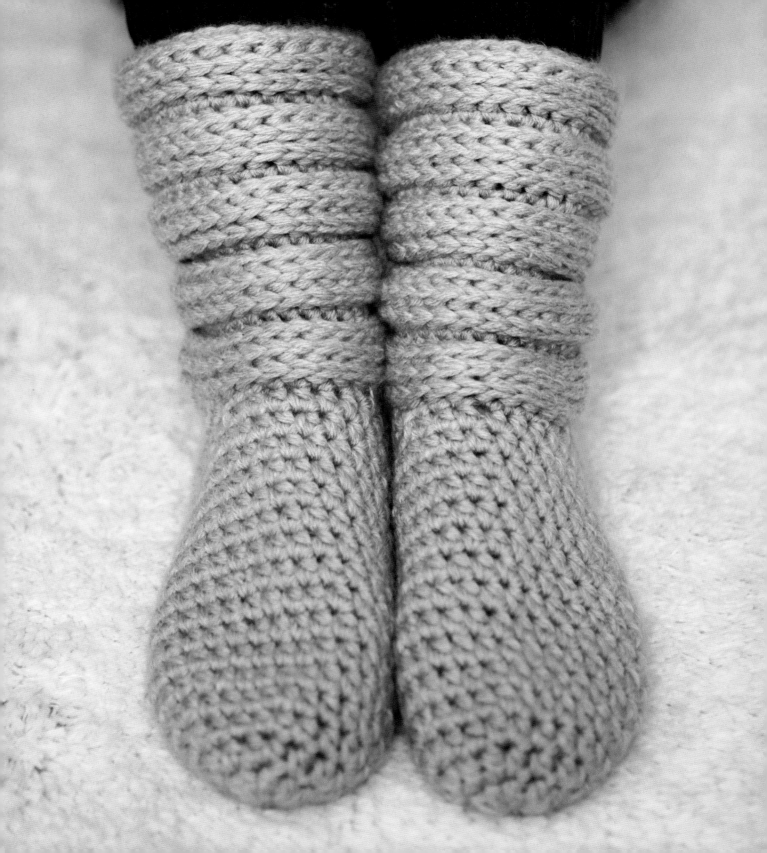

slouchy slipper
BOOTS

BY LISA VAN KLAVEREN

A little bit of luxury for your feet! These comfy slipper boots are quick and easy to stitch and make the perfect gift for yourself or a loved one.

FINISHED SIZE
Directions are given for Women's sizes Small (5–7). Changes for Medium (7½–9) and Large (9½ and larger) are in parentheses.

Finished measurements: 9½ (10, 10½)" (24 [25.5, 26.5] cm) long.

Project shown is size Medium (10" [25.5] cm long).

YARN
Worsted weight (#4 Medium).

SHOWN HERE: Premier Yarns Deborah Norville Collection Everyday Heather (100% acrylic; 180 yd/165 m; 3.5 oz/100 g): #13 Fog Heather, 4 skeins.

NOTIONS
Yarn needle.

HOOK
Size I-9 (5.5 mm)

GAUGE
12 hdc and 10 rows hdc = 4" (10 cm). *Adjust hook size if necessary to obtain correct gauge.*

NOTES
• You may vary the height of the ribbed cuff as desired.

• Project is worked using 2 strands held together to create a bulky weight.

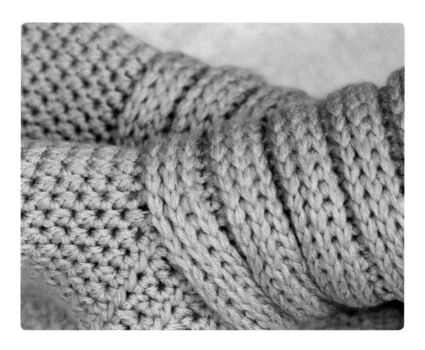

BOOTS
(MAKES 2)

Starting at toe, ch 4 and join into a ring with a sl st in first ch.

RND 1: (RS) Ch 2 (counts as hdc here and throughout), 9 hdc in ring do not join. Work in a spiral placing a marker in first st of rnd, moving marker up as work progresses. (10 hdc)

RND 2: *Hdc in next st, 2 hdc in next st; rep from * around. (15 hdc)

RND 3: *Hdc in each of next 2 sts, 2 hdc in next st; rep from * around. (20 hdc)

RND 4: *Hdc in next 3 sts, 2 hdc in next st; rep from * around. (25 hdc)

RND 5: Hdc in each st around.

RNDS 6–14 (15, 16): Rep Rnd 5.

At end of last rnd, join with a sl st in next hdc.

Work now progresses in rows.

ROW 1: Ch 2, hdc in each of next 18 sts, turn. (19 hdc)

ROWS 2–8: Ch 2, hdc in each st across turn.

Do not fasten off.

HEEL SEAM

ROW 1: With RS facing, fold last row of slipper in half downward, ch 1, working throughout double thickness, matching sts, sl st in each st across to create Heel Seam, turn.

ROW 2: Ch 1, sl st in each st across to top of ankle. Turn Boot RS out.

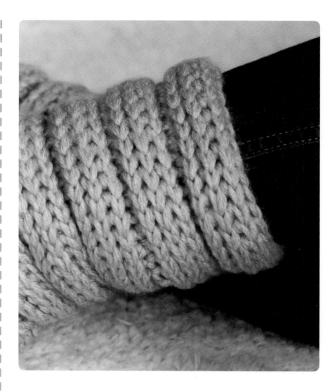

CUFF

RND 1: Ch 2, work 29 hdc evenly spaced around entire ankle, join with a sl st in top of beg ch-2. (30 hdc)

RNDS 2–4: Ch 2, BPhdc around post of each st around, join with a sl st in top of beg ch-2.

RND 5: Ch 2, hdc in each st around, join with a sl st in top of beg ch-2.

RNDS 6–20: Rep Rnds 2–5 (3 times); then rep Rnds 2–4.

Fasten off.

FINISHING

Weave in ends.

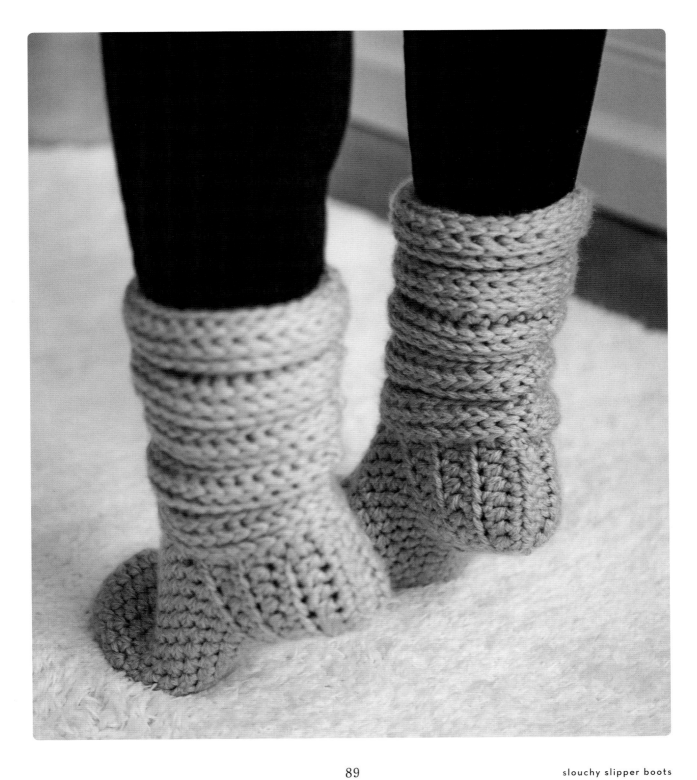

slouchy slipper boots

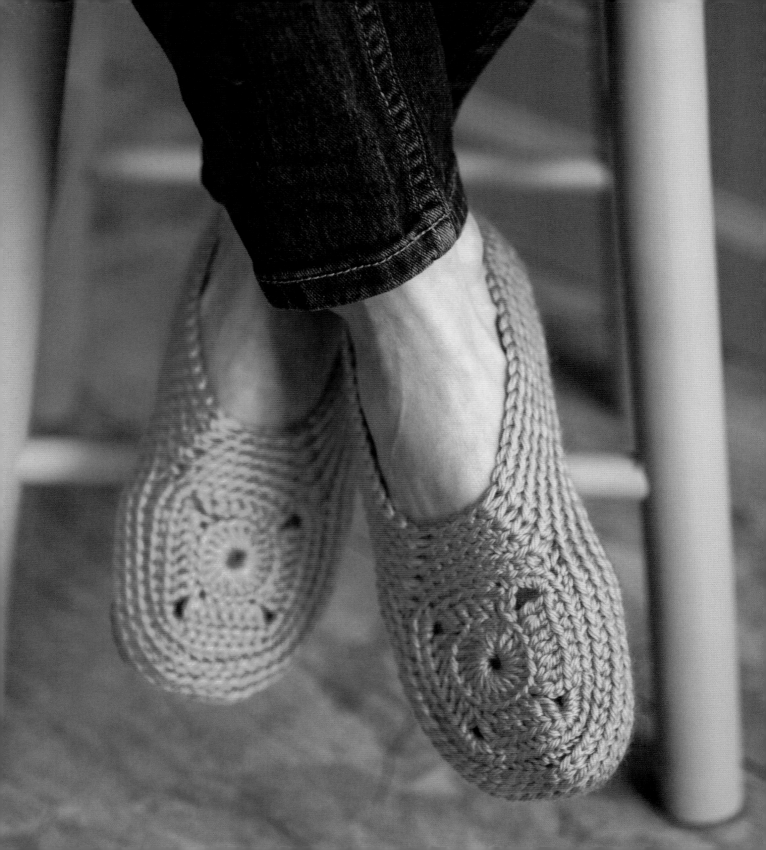

sweet granny square SLIPPERS

BY MÉLISSA THIBAULT

Put a spring in your step with these cheerful, quick-to-make slippers. Only one granny motif required!

FINISHED SIZE
Women's size Small.

Slippers measure 9" (23 cm) long, unstretched.

YARN
Worsted weight (#4 Medium).

SHOWN HERE: Red Heart Soft Touch (100% acrylic; 290 yd/265 m; 5 oz/141 g): #9440 Light Grey Heather, 1 skein (A); Bernat Satin (100% acrylic; 200 yd/183 m; 3.5 oz/100 g): #4609 Goldenrod, 1 skein (B).

HOOK
Size 7 (4.5 mm).

NOTIONS
Yarn needle; stitch markers.

GAUGE
16 sts and 6 rows dc = 4" (10 cm). *Adjust hook size if necessary to obtain correct gauge.*

special stitches

Single crochet 2 together (sc2tog)

[Insert hook in next st, yarn over, draw yarn through st] twice, yarn over, draw yarn through 3 loops on hook.

Single crochet 3 together (sc3tog)

[Insert hook in next st, yarn over, draw yarn through st] 3 times, yarn over, draw yarn through 4 loops on hook.

SOLE

With A, ch 29.

RND 1: (RS) Dc in 3rd ch from hook, dc in each of next 25 ch, 5 dc in next ch, working across opposite side of foundation ch, dc in each of next 25 ch, 3 dc in the next st, join with a sl st in top of beg ch-3. Beg ch-3 counts as dc. (60 dc)

RND 2: Ch 3 (counts as dc here and throughout), dc in the same st, 2 dc in next st, dc in next st, 2 dc in next st, 2 dc in next st, 3 dc in next st, 2 dc in next st, 2 dc in next st, dc in each of next 25 sts, 2 dc in next st, 2 dc in next st, 3 dc in next st, join with sl st in the top of beg ch 3. (72 dc)

RND 3: Ch 3, dc in next st, 2 dc in next st, dc in each of next 27 sts, 2 dc in next st, dc in next 3 sts, 3 dc in next st, dc in each of next 3 sts, 2 dc in next st, dc in each of next 27 sts, 2 dc in next st, dc in each of next 3 sts, 3 dc in next st, dc in next st, join with a sl st in top of beg ch-3. (80 dc)

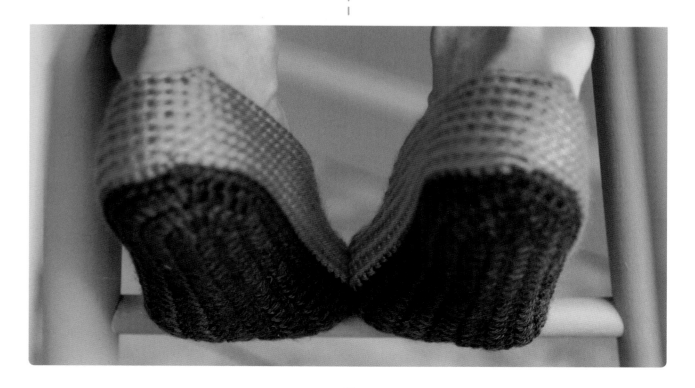

RND 4: Ch 1, 2 sc in first st, sc in each of next 33 sts, 2 sc in next st, sc in each of next 2 sc, 3 sc in next st, sc in each of next 2 sts, 2 sc in next st, sc in each of next 33 sts, 2 sc in next st, sc in each of next 2 sts, 3 sc in next st, sc in each of next 2 sts, join with a sl st in the first sc. (88 sc) Fasten off A.

Put a marker in the middle st of last rnd on both front and back of Sole.

SQUARE

With B, ch 4, join into a ring with a sl st in first ch.

RND 1: Ch 3, 19 dc in ring, join with a sl st in top of beg ch-3. (20 dc)

RND 2: Ch 3, working in back loop only, dc in same st, *dc in each of next 3 sts, 2 dc in next st, ch 2, 2 dc in next st; rep from * twice, dc in each of next 3 sts, 2 dc in next st, ch 2, join with a sl st in top of beg ch-3.

RND 3: Ch 1, working in back loop only, sc in first st, sc in each of next 6 sts, 4 sc in next ch-2 sp, *sc in each of next 7 sts, 4 sc in next ch-2 sp; rep from * twice, join with a sl st in top of beg ch-3. Fasten off B.

SLIPPER

RND 1: With RS facing, join B with a sl st in marked center st on back of Sole, ch 1, working in back loops only, sc in each st around, join with a sl st in first sc. (88 sc)

RNDS 2–4: Ch 1, working in back loops only, sc in each st around, join with a sl st in first sc. Don't fasten off.

stitch key

⬭ = chain (ch)

• = slip st (sl st)

+ = single crochet (sc)

\dagger = double crochet (dc)

⌒ = worked in back loop only

ASSEMBLY

With RS facing, with one side of Square centered across front end of last rnd of Slipper, sew Square to corresponding sts of Slipper across 33 sts on 3 sides of Square, leaving 55 sts on back end of Slipper unjoined.

CONTINUE SLIPPER

RND 5: Ch 1, working in back loops only, sc in each of next 27 sts, sc2tog over next st on Slipper and corner st of Square, sc in each of next 9 sts onside of Square), sc2tog over corner st of Square and next st on Slipper, sc in each st around, join with a sl st in first sc. (64 sc)

RND 6: Ch 1, working in back loops only, sc in each of next 26 sts, sc3tog over next 3 sts, sc in each of next 7 sts, sc3tog over next 3 sts, sc in each st around, join with a sl st in first sc. (60 sc)

RND 7: Ch 1, working in back loops only, sc in each of next 25 sts, sc3tog over next 3 sts, sc in each of next 5 sts, sc3tog over next 3 sts, sc in each st around, join with a sl st in first sc. (56 sc)

RND 8: Ch 1, working in back loops only, sc in each of next 24 sts, sc3tog over next 3 sts, sc in each of next 3 sts, sc3tog over next 3 sts, sc in each around, join with a sl st in first sc. (52 sc) Fasten off B.

FINISHING

Weave in ends.

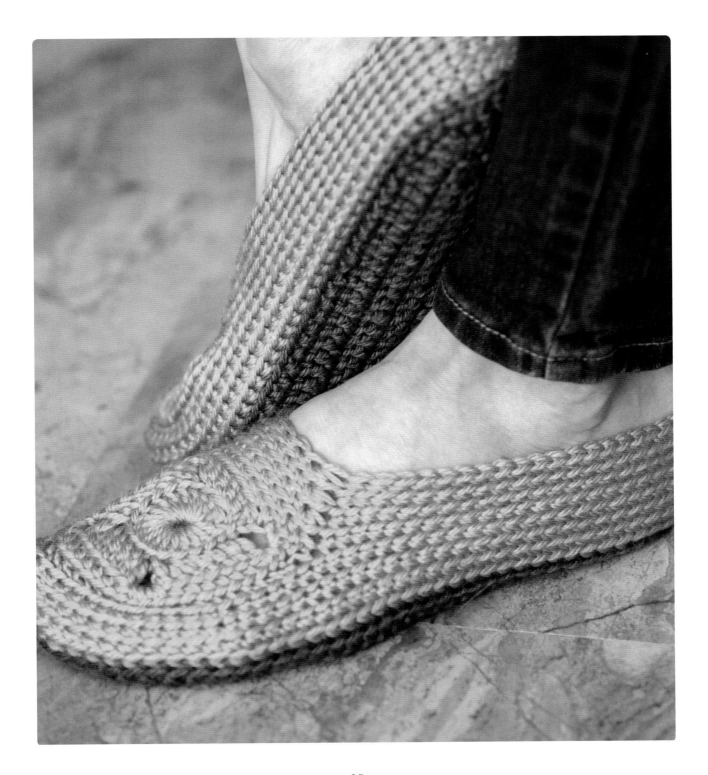

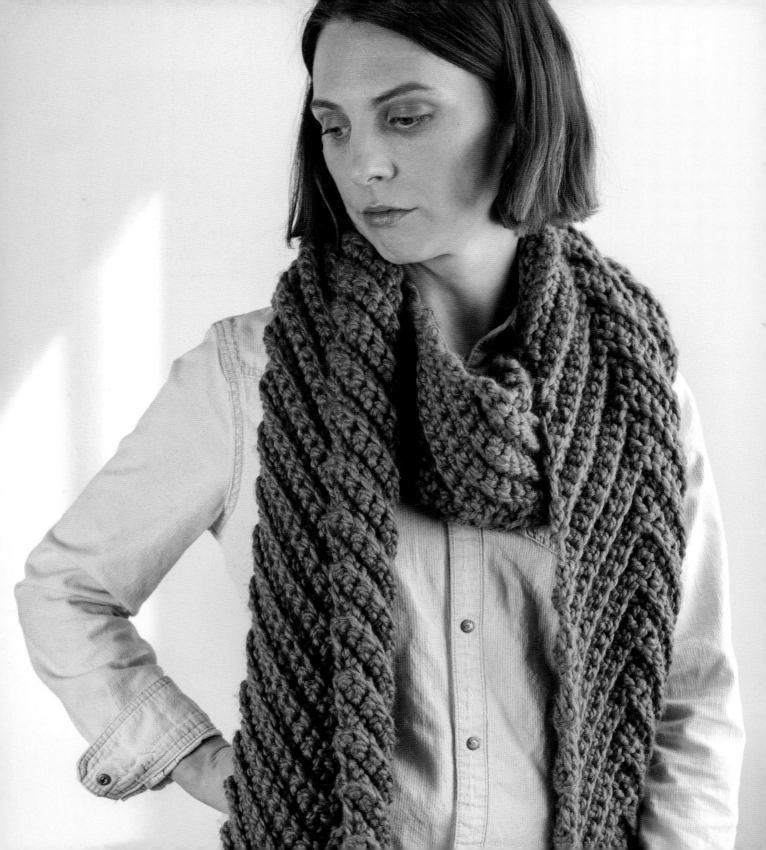

chevron
SCARF

BY AMY KLEINPETER

Not just any scarf—a dramatic, warm, lovely piece that will make you feel enveloped in a hug.

FINISHED SIZE
Scarf measures 92" (234 cm) long excluding fringe x 9" (23 cm) wide.

YARN
Bulky weight (#6 Super Bulky).

SHOWN HERE: Lion Brand Wool-Ease Thick & Quick (80% acrylic/20% wool; 106 yd/97 m; 6 oz/170 g): #122 Taupe, 4 skeins.

NOTIONS
Yarn needle.

HOOK
Size M-13 (9 mm).

GAUGE
8 sts and 8 rows in sc worked in back loop only = 4" (10 cm). *Adjust hook size if necessary to obtain correct gauge.*

special stitches

**2-double crochet cluster
(2-dc cl)**

[Yarn over, insert hook in st or sp,
yarn over and pull up loop, yarn
over and draw through 2 loops on
hook] twice in same st or sp, yarn
over and draw through all 3 loops
on hook.

**3-double crochet cluster
(3-dc cl)**

[Yarn over, insert hook in st or sp,
yarn over and pull up loop, yarn
over and draw through 2 loops on
hook] 3 times in same st or sp,
yarn over and draw through all 4
loops on hook.

V-stitch (V-st)

(Dc, ch 2, dc) in same st or sp.

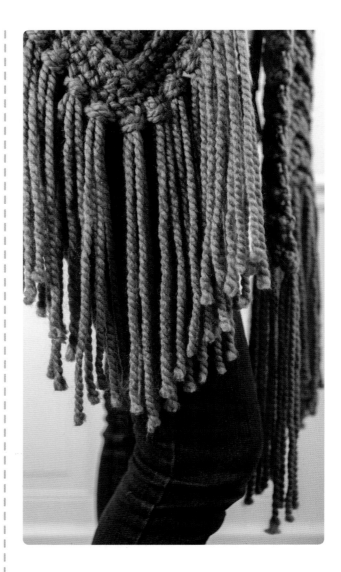

INSTRUCTIONS

Cut 60 strands of yarn 22" (56 cm) long for fringe and set
aside.

Ch 27.

ROW 1: 2 sc in 2nd ch from hook, sc in each of next 11
ch, skip next 2 ch, sc in each of next 11 ch, 2 sc in last ch,
turn. (26 sc)

ROWS 2–120: Ch 1, working in back loops only, 2 sc
in first st, sc in each of next 11 sts, skip next 2 sts, sc in
each of next 11 sts, 2 sc in last st, turn. (26 sts) Fasten off.

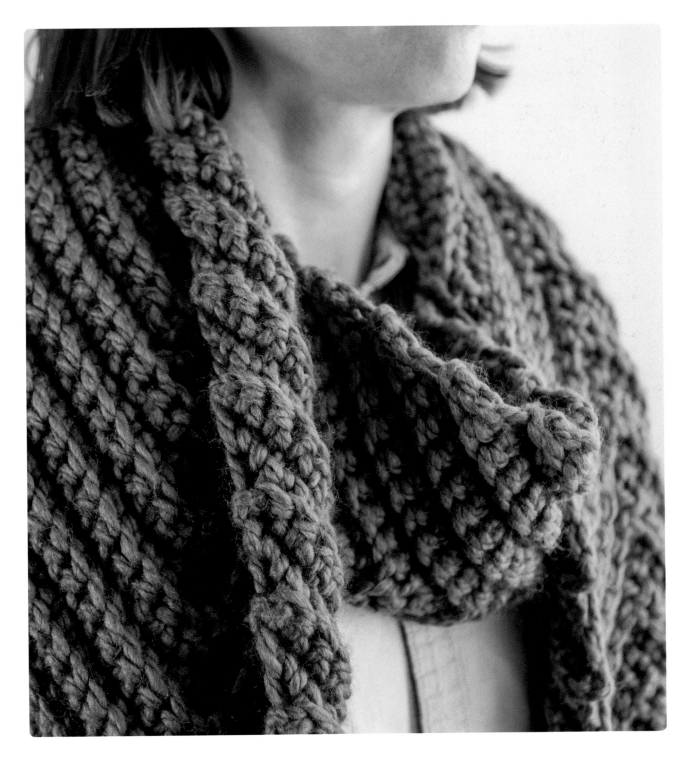

chevron scarf

stitch key

⌒ = chain (ch)

+ = single crochet (sc)

⌢ = worked in back loop only

FINISHING

Weave in ends. Using 2 strands of yarn for each fringe, single-knot one fringe in every other st across each end of scarf. Trim even as desired.

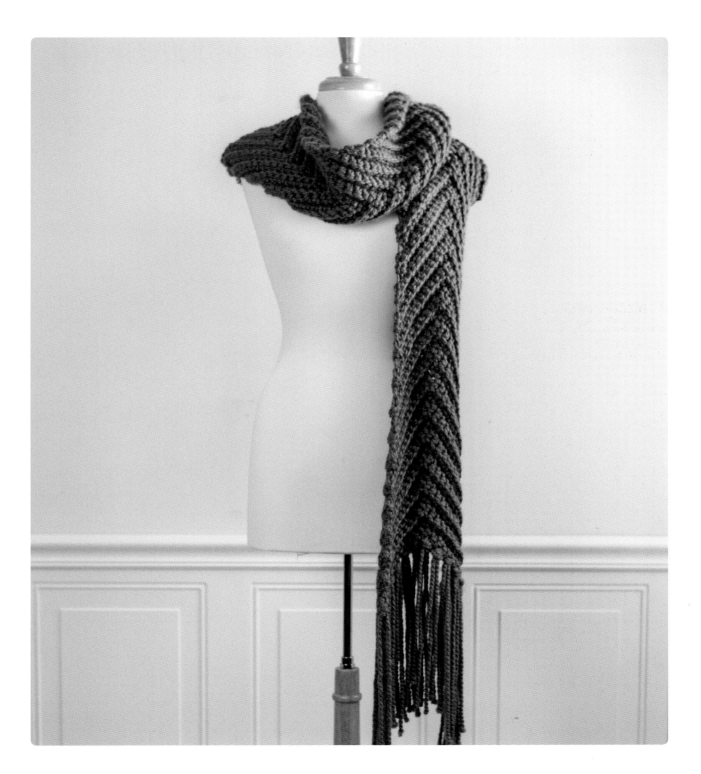

abbreviations

beg	beginning
bet	between
CC	contrasting color
cm	centimeter
ch-sp	chain space
dec	decrease
ea	each
est	established
flp	through front loop only
fsc	foundation single crochet
g	gram
incr	increase
lp	loop
MC	main color
m	marker
opp	opposite
pm	place marker
prev	previous
rem	remaining
rep	repeat
rnd	round
RR	row repeat
RS	right side
sh	shell
Sk	Skip
SR	stitch repeat
st	stitch
tch	turning chain
tog	together
WS	wrong side
yd	yard
yo	yarn over
*****	repeat instructions following asterisk as directed
******	repeat all instructions between asterisks as directed
()	perform stitches in same indicated stitches
()	alternate instructions or measurements
[]	work bracketed instructions specified number of times

techniques

ADJUSTABLE RING

Make a large loop with the yarn. Holding the loop with your fingers, insert hook into loop and pull working yarn through loop. Yarn over hook, pull through loop on hook. Continue to work indicated number of stitches into loop. Pull on yarn tail to close loop.

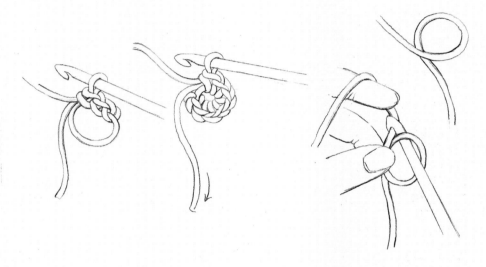

BACK POST DOUBLE CROCHET (BPDC)

Yarn over hook, insert hook from back to front, to back again around the post of stitch, yarn over hook, draw yarn through stitch, [yarn over hook, draw yarn through 2 loops on hook] twice.

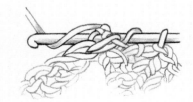

DOUBLE CROCHET (DC)

If you are starting a new pattern you'll begin by making a foundation chain. Chain the number of stitches you want for your dc row plus three. So, if you want a row of five dc stitches you want to begin with eight chains. You will skip the first three chains, which count as your turning chains, and follow the steps below:

Yarn over, insert hook in fourth chain from hook, yarn over and pull up loop (3 loops on hook; **Figure 1**), yarn over and draw through 2 loops (**Figure 2**), yarn over and draw through remaining 2 loops (**Figure 3**). *Yarn over, insert hook in next chain, yarn over and pull up loop (3 loops on hook; **Figure 1**), yarn over and draw through 2 loops (**Figure 2**), yarn over and draw through remaining 2 loops (**Figure 3**); repeat from*.

For subsequent rows:

Chain three and turn to begin next row. *Yarn over, insert hook in stitch, yarn over and pull up loop (3 loops on hook; **Figure 1**), yarn over and draw through 2 loops (**Figure 2**), yarn over and draw through remaining 2 loops (**Figure 3**); repeat from *.

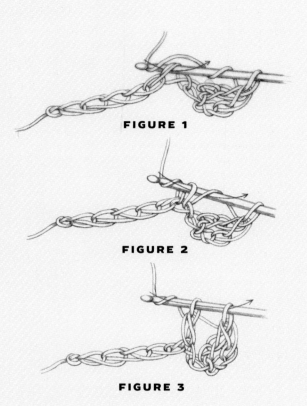

FIGURE 1

FIGURE 2

FIGURE 3

HALF DOUBLE CROCHET (HDC)

If you are starting a new pattern you'll begin by making a foundation chain. Chain the number of stitches you want for your hdc row plus two. So, if you want a row of five hdc stitches you want to begin with seven chains. You will skip the first two chains, which count as your turning chains, and follow the steps below:

Yarn over, insert hook in third chain from hook, yarn over and pull up loop (3 loops on hook), yarn over (**Figure 1**) and draw through all loops on hook (**Figure 2**). *Yarn over, insert hook in next chain, yarn over and pull up loop (3 loops on hook), yarn over **Figure 1**) and draw through all loops on hook (**Figure 2**); repeat from *.

For subsequent rows:

Chain two and turn to begin next row. *Yarn over, insert hook in stitch, yarn over and pull up loop (3 loops on hook), yarn over (Figure 1) and draw through all loops on hook (Figure 2); repeat from *.

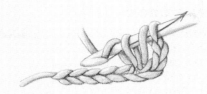

FIGURE 1

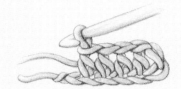

FIGURE 2

MATTRESS STITCH

With RS facing, use threaded needle to pick up one bar between first 2 stitches on one piece (**Figure 1**), then corresponding bar plus the bar above it on other piece (**Figure 2**). *Pick up next two bars on first piece, then next two bars on other (**Figure 3**). Repeat from * to end of seam, finishing by picking up last bar (or pair of bars) at the top of first piece.

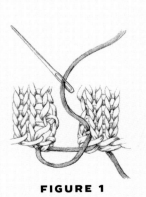

FIGURE 1

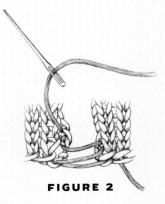

FIGURE 2

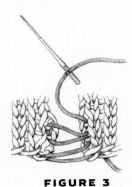

FIGURE 3

105

SINGLE CROCHET (SC)

Single crochet is on e of the more common stitches you'll run across in crochet patterns, and is especially popular for use in amigurumi designs. Because of its short height, it creates a more dense fabric than other stitches.

If you are starting a new pattern you'll begin by making a foundation chain. Chain the number of stitches you want for your sc row plus one. So, if you want a row of five sc stitches you want to begin with six chains. You will skip the first chain, which counts as your turning chain, and follow the steps below:

Insert hook in second chain from hook, yarn over and pull up loop (**Figure** 1), yarn over and draw through both loops on hook **Figure** 2). *Insert hook in next chain, yarn over and pull up loop (**Figure** 1), yarn over and draw through both loops on hook (**Figure** 2); repeat from *.

For subsequent rows:

Chain one and turn to begin next row. *Insert hook in stitch, yarn over and pull up loop (**Figure** 1), yarn over and draw through both loops on hook (**Figure** 2); repeat from *.

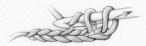

FIGURE 1

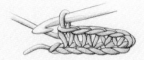

FIGURE 2

TREBLE CROCHET (TR)

*Yarn over 2 times, insert hook in stitch, yarn over and pull up loop (4 loops on hook; **Figure** 1), yarn over and draw through 2 loops (**Figure** 2), yarn over and draw through 2 loops, yarn over and draw through remaining 2 loops (**Figure** 3); repeat from *.

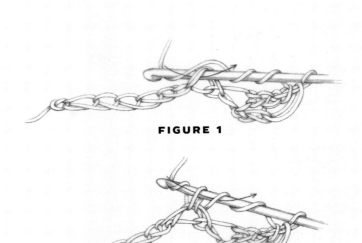

FIGURE 1

FIGURE 2

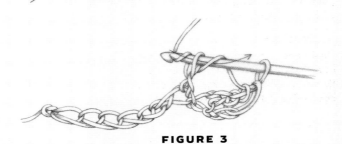

FIGURE 3

techniques

about the designers

ANNEMARIE BENTHEM is a Dutch designer who lives in Delft with her Spanish stray cat and her boyfriend. She learned to crochet in 2010, and shortly after she started an Etsy shop in which she sells patterns and finished goods. She has a blog both in Dutch and English, and she is known for her use of bright and happy colors. She published two books in the Netherlands and has contributed to several books and magazines within and outside the Netherlands.

website: www.annemarieshaakblog.blogspot.com

etsy shop: www.annemariesbreiblog.etsy.com

ADRIENNE BRIGHAM has been an avid crocheter for over ten years. She enjoys teaching others as well as challenging herself with new techniques and by creating new designs. In addition to spending time crocheting, Adrienne is happily married and stays home tending to her two beautiful children.

website: www.mangomum.net

etsy shop: www.mangomum.etsy.com

JENNIFER BROWN lives with her husband and two daughters in Helena, Montana. In between crocheting and spending time with her family, she enjoys running, camping, and reading, and is always on the lookout for new and creative projects to start!

website: www.montanadaisygirl.com

etsy shop: www.montanadaisygirl.etsy.com

KATE DOHN learned to crochet at the age of eight. Since 2010, she has been designing crochet patterns and handmaking crochet hats and accessories for her online boutique, the Good Shnit. When she's not crocheting she can be found tending her vegetable and herb gardens in the foothills of California. Living close to nature provides inspiration for each one of her designs.

website: www.thegoodshnit.com

etsy shop: www.thegoodshnit.etsy.com

ERIN HANSEN was raised in Arizona and currently resides in Connecticut with her husband and seven-year-old son. She is a lover of crafts, cooking, home décor, and just about anything DIY. Crochet was something that she really took to, and she soon began designing her own patterns. She currently has an Etsy shop where she specializes in crochet hats and accessories. There you will find finished items as well as her pattern designs.

etsy shop: www.simplymadebyerin.etsy.com

DESIREE HOBSON is a fiber enthusiast and passionate crochet designer. Her work has been sold through Etsy, The Grommet, and at several small boutiques nationally. She has also been featured as an artist in Seattle Met and on KOMO News. Desiree currently lives in a small town on the outskirts of Seattle.

JULIE KING started designing and selling her own crochet patterns in 2006, shortly after discovering Etsy and just a couple years after learning to crochet. Always having been a crafty person, designing came naturally to Julie, who even as a child enjoyed creating her own sewing patterns and craft projects. Today, Julie lives in Southern California where she has worked as a full-time crochet designer and blogger since 2010. She loves continuing to learn new stitches and techniques to incorporate in her designs and enjoys teaching others via her blog and YouTube channel.

website: www.gleefulthings.com

etsy shop: www.gleefulthingscrochet.etsy.com

youtube: www.youtube.com/user/GleefulThings

LISA VAN KLAVEREN first held a crochet hook at age three and grew up playing with yarn and making gifts for friends and family. She published her first original patterns in the late 1990s while a college student at the University of Wisconsin. Lisa has been designing full-time since 2008 and has created over 400 original designs while also keeping busy as a stay-at-home mom. She currently lives near Auckland, New Zealand, with her husband Gilbert and three young daughters.

website: www.hollanddesignscrochet.com

etsy shop: www.hollanddesigns.etsy.com

AMY KLEINPETER is the designer behind Swellamy Crochet. She has been crocheting since childhood and designing patterns for four years; most recently she has designed for the San Francisco Opera. Amy is an elementary school teacher and a mom of two from central Illinois.

website: www.swellamy.com

etsy shop: www.swellamy.etsy.com

CARLA MALCOMB is inspired by home and family , and simplicity is her style. As a young girl, Carla enjoyed sitting with her mom to watch her crochet. Her mother explained the logic behind the stitches and showed Carla how to turn imagination into creation. She has been crocheting ever since. Today, you can find her designs on Ravelry as cm2tog.

website: www.mouseandthimble.com

etsy shop: www.mouseandthimble.etsy.com

MARTHA MCKEON is currently living in coastal southern Connecticut near her two grown daughters and two little grandsons, having retired from a long career in running a garden design and maintenance business. The beach and her backyard garden are a constant source of inspiration for Martha's handcraft pursuits. Having been a serious pattern collector for many years, knit and crochet pattern design was a natural evolvement from her tendency to create one-of-a-kind items from her ideas.

etsy shop: www.longbeachdesigns.etsy.com

TARA MURRAY is the designer behind the name Mamachee. Tara's very lovely Mama taught her to crochet when she was a teen, but it didn't catch on until she was pregnant with her first child in 2006. Tara made so many hats for that baby and quickly became a crochet pattern hoarder. She eventually became good enough to start tweaking patterns before then coming up with her own designs. With the encouragement of sweet friends, Tara wrote up her first original pattern in 2008 and has hardly put her hooks down since.

website: htp://mamachee.com

etsy shop: www.mamachee.etsy.com

MANDY O'SULLIVAN is a self-confessed crochet addict who is obsessed with all things design. Her craft and design blog is her happy place where she shares her love for creative living. A strong believer in the therapeutic benefits of crafts, she is the founder of @craftastherapy on Instagram, a large online craft community that promotes crafting as a way to relieve stress. Most of Mandy's crochet designs are born in her rural home in New South Wales, Australia.

website: www.redagape.com.au

MÉLISSA THIBAULT lives in a small town in Quebec, Canada, and is a mother of a wonderful little boy. Her friends call her Meli, which inspired the name of her shop, Mélie, a handmade fashion accessories and crochet pattern shop. She started selling patterns on Etsy in 2012 and added fashion accessories products in 2015.

etsy shop: www.meliecollection.etsy.com

JUSTINE WALLEY is an avid crocheter and hat designer with more than 100 original crochet hat designs. She strives to utilize unique stitches and design elements to create classy, wearable hats for any style.

etsy shop: www.alysecrochet.etsy.com

resources

BERNAT
Distributed by Spinrite
320 Livingston Ave. So.
Box 40
Listowel, ON
Canada N4W 3H3
(800) 351-8356
www.yarnspirations.com

LION BRAND YARN
135 Kero Rd.
Carlstadt, NJ 07072
(800) 258-YARN (9276)
www.lionbrand.com

LOOPS & THREADS
(800) MICHAELS (642-4835)
www.michaels.com

PATONS
Distributed by Spinrite
320 Livingston Ave. So.
Box 40
Listowel, ON
Canada N4W 3H3
(800) 351-8356
www.yarnspirations.com

PHILDAR
www.phildar.fr

PREMIER YARNS
2800 Hoover Rd.
Stevens Point, WI 54481
(888) 458-3588
www.premieryarns.com

RED HEART
P.O. Box 12229
Greenville, SC 29612-0229
(800) 648-1479
www.shopredheart.com

RICO DESIGN
www.rico-design.de/en/home

WILLOW YARNS
2800 Hoover Rd.
Stevens Point, WI 54481
(855) 279-4699
www.willowyarns.com

www.fwmedia.com

12 11 10 09 08 5 4 3 2 1

Distributed in Canada by Fraser Direct
100 Armstrong Avenue
Georgetown, ON, Canada L7G 5S4
Tel: (905) 877-4411

Distributed in the U.K. and Europe by F&W MEDIA INTERNATIONAL
Brunel House, Newton Abbot, Devon, TQ12 4PU, England
Tel: (+44) 1626 323200, Fax: (+44) 1626 323319
Email: enquiries@fwmedia.com

SRN: 16CR11
ISBN-13: 978-1-63250-495-1

editors KERRY BOGERT AND ERICA SMITH

technical editor KAREN MANTHEY

designer KARLA BAKER

production coordinator VICTOR WATCH

photographer CHRIS DEMPSEY PHOTOGRAPHY

METRIC CONVERSION CHART

To convert	to	multiply by
Inches	Centimeters	2.54
Centimeters	Inches	0.4
Feet	Centimeters	30.5
Centimeters	Feet	0.03
Yards	Meters	0.9
Meters	Yards	1.1

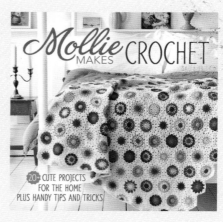